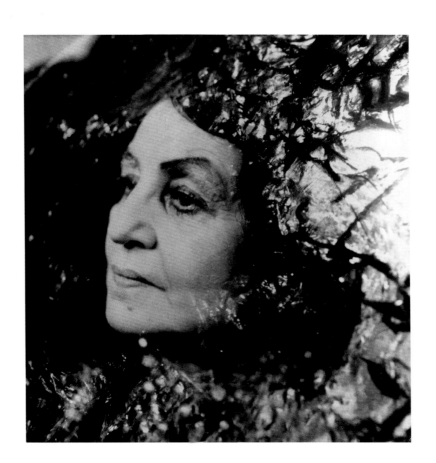

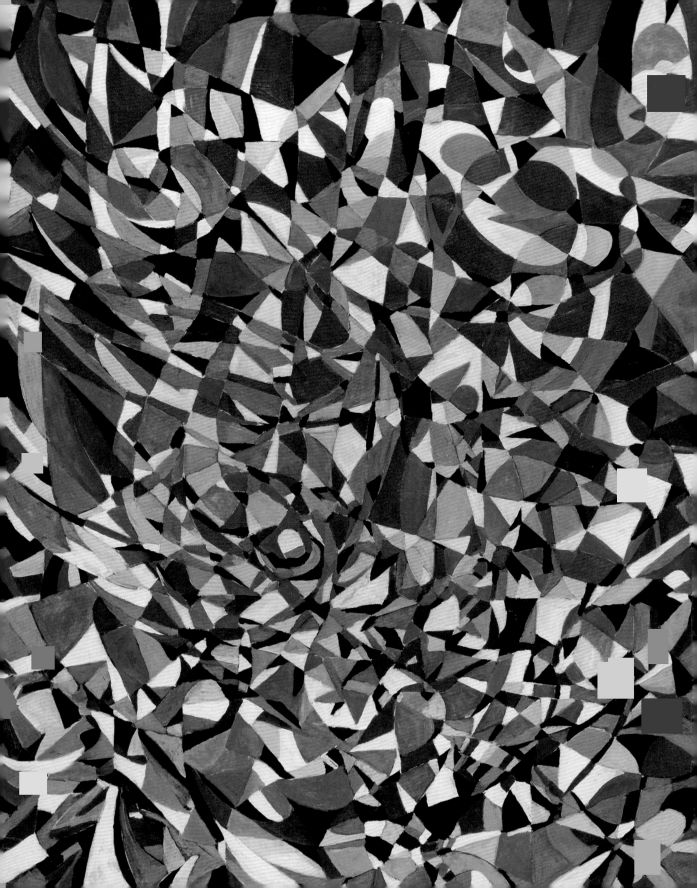

FAHRELNISSA
ZEID

Edited by Kerryn Greenberg

WITH CONTRIBUTIONS BY
Kerryn Greenberg, Adila Laïdi-Hanieh,
Vassilis Oikonomopoulos, Necmi Sönmez
and Sarah Wilson

TATE PUBLISHING

First published 2017 by order of the Tate Trustees
by Tate Publishing, a division of Tate Enterprises Ltd,
Millbank, London SW1P 4RG
www.tate.org.uk/publishing

on the occasion of the exhibition

FAHRELNISSA ZEID

Tate Modern, London
13 June – 8 October 2017

Deutsche Bank KunstHalle, Berlin
19 October 2017 – 25 March 2018

Nicolas Ibrahim Sursock Museum, Beirut
27 April – 1 October 2018

The exhibition at Tate Modern is sponsored by
Deutsche Bank

Sponsored by
Deutsche Bank

With additional support from the Fahrelnissa Zeid
Exhibition Supporters Circle:

Darat al Funun – The Khalid Shoman Foundation
Mr Mehmet Riza Erdem and Mrs Elif Erdem
Mohammad and Mahera Abu Ghazaleh
SAHA – Supporting Contemporary Art from Turkey

A catalogue record for this book is available
from the British Library

ISBN 978 1 84976 456 8

Distributed in the United States and Canada
by ABRAMS, New York

Library of Congress Control Number: applied for

Designed by Philip Lewis
Colour reproduction by DL Imaging Ltd, London
Printed and bound by Conti, Italy

COVER Fahrelnissa Zeid, *The Break of the Atom and
Vegetal Life* 1962 (detail of no.59)
HALF TITLE Zeid photographed through one
of her *Paléokrystalos*, Paris, late 1960s. The Raad Zeid
Al-Hussein Collection
FRONTISPIECE *Towards a Sky* 1953 (*Vers un ciel*) (detail)
Oil paint on canvas, 593 × 201, Courtesy Sotheby's,
London
PAGE 6 Zeid in her studio at 39, rue de Grenelle,
Paris, 1954. The Raad Zeid Al-Hussein Collection

Measurements of artworks are given in
centimetres, height before width

Contents

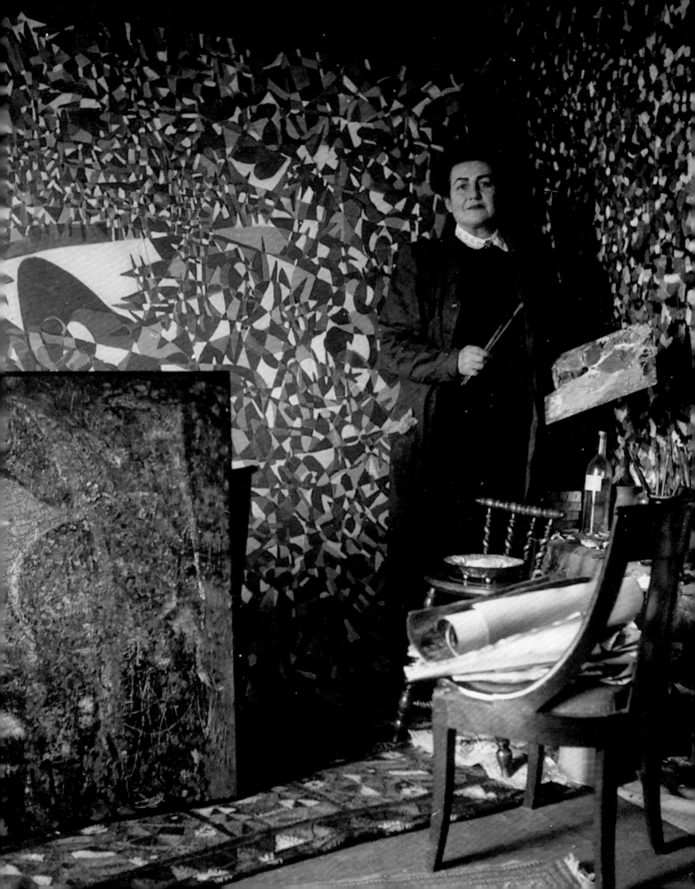

Directors' Foreword

In the 1980s, Fahrelnissa Zeid wrote to a prominent American businessman asking to paint his portrait. Working from a photograph he sent her, Zeid created a larger than life impression of the young man in a tuxedo with sweeping blonde hair and ice-blue eyes. Across his chest, in large Arabic letters, she painted the subject's name: Donald Trump. At the time Trump was still in the process of refining his public persona and was a very unlikely subject for a woman artist living in Amman, Jordan, especially one well into her eighties. There was however nothing ordinary about Fahrelnissa Zeid.

Born into an elite Ottoman family in Istanbul at the turn of the twentieth century, Zeid refused to be bound by social conventions or expectations, becoming one of the first modern woman painters in Turkey. When her family was struck by tragedy on several occasions, she immersed herself in her art, making ever more ambitious and experimental works. She was feisty, charismatic and prolific, and received widespread recognition during her life, exhibiting across Europe, the Middle East and the United States from 1945 until her death in 1991. Yet, outside Turkey and Jordan, her name is not well known today. Through this exhibition and its accompanying catalogue we seek to redress that by not only celebrating her extraordinary career, but by revealing Zeid as an important figure in the international story of abstract art.

The retrospective will open at Tate Modern, before travelling to Deutsche Bank KunstHalle in Berlin, and the Nicolas Ibrahim Sursock Museum in Beirut. Fahrelnissa Zeid is an ideal choice for the third collaboration between Tate and the Deutsche Bank KunstHalle, with Deutsche Bank on this occasion sponsoring the exhibition in London, since Zeid lived in Berlin from 1935–8 while her husband Prince Zeid Al-Hussein was Ambassador of the Kingdom of Iraq to Germany. We are particularly delighted that the exhibition will also be seen at the Nicolas Ibrahim Sursock Museum in Beirut, since Zeid moved between the Middle East and Europe throughout her life, fusing European approaches to abstract art with Byzantine, Islamic and Persian influences to create her own unique visual vocabulary.

Special thanks are due to Kerryn Greenberg and Vassilis Oikonomopoulos, without whom this exhibition would not have been possible. It is through their original research and deep commitment to the project that our audiences will have an opportunity to experience the remarkable visual legacy of Zeid's extraordinary life.

Frances Morris
Director, Tate Modern

Franziska Kunz
Global Head of Art, Deutsche Bank

Zeina Arida
Director, Nicolas Ibrahim Sursock Museum

Acknowledgements

This ambitious retrospective and its accompanying catalogue would not have been possible without the unwavering support of Fahrelnissa Zeid's family, in particular Prince Raad Zeid Al-Hussein and Princess Majda Raad Z. Al-Hussein and their son Prince Mired Raad Z. Al-Hussein. We have enjoyed extraordinary hospitality in Amman during the course of researching and organising this exhibition and had the immense pleasure of learning about the artist's life and work from those closest to her. It is hard to imagine a more generous and enthusiastic estate to collaborate with and we are delighted the family have willingly lent so many works from their collection to the exhibition.

The Istanbul Museum of Modern Art has an unrivalled collection of Fahrelnissa Zeid's work and are major lenders to this exhibition. Levent Çalıkoğlu, Director, and Gözen Müftüoğlu Aksan, Registrar and Exhibition Manager, and their colleagues at Istanbul Museum of Modern Art have supported this project from the outset, giving charitably of their time and expertise. We thank them for sharing the masterpieces of their collection.

The Ludwig Forum für Internationale Kunst, Aachen, Musée d'Art Moderne de la Ville de Paris and The Khalid Shoman Collection have generously loaned works to this exhibition. Special thanks are also due to the following lenders who have backed this project wholeheartedly: Berrak and Nezih Barut Collection, Sema and Barbaros Çağa Collection, Ceyda and Ünal Göğüş Collection, Sevtap and Tolga Kabataş Collection, Larock Granoff Collection, Ela Sefer and Z. Yildirim Family Collection.

We would like to thank Deutsche Bank for their support, especially Thorsten Strauß, who provided the impetus for a special partnership and long-term collaboration. A very special thanks to Franziska Kunz, Global Head of Art, Deutsche Bank, for recognising Fahrelnissa Zeid as an extraordinary artist and partnering with us to bring the exhibition to audiences in Berlin. Svenja Gräfin von Reichenbach, Head of Deutsche Bank KunstHalle, and Sara Bernshausen, Deputy Head, with their wonderful team deserve special recognition for being a pleasure to work with at the Berlin venue. We have enjoyed the support of Mary Findlay and Eleanor Palfrey with Deutsche Bank sponsoring the exhibition in London.

We are delighted that this exhibition will also be seen in Beirut at the Nicolas Ibrahim Sursock Museum. Thank you to the Executive Committee and Board of Trustees, Zeina Arida, Director, Nora Razian, Head of Programs and Exhibitions and Yasmine Chemali, Head of Collections, at the Sursock Museum for overcoming all the obstacles. We hope that this is the beginning of future collaborations.

Our ability to stage this exhibition has been greatly enhanced by the generosity of a committed group of donors. We are grateful to Darat al Funun – The Khalid Shoman Foundation, Mohammad and Mahera Abu Ghazaleh, and Mr Mehmet Riza Erdem and Mrs Elif Erdem. We are also indebted to SAHA, and in particular Füsun Eczacıbaşı and Merve Çağlar, Chair and Director of SAHA respectively, for their advocacy and generous support of this exhibition. Special thanks to Suha Shoman, one of Zeid's former students, who has long championed the artist's work and has helped in numerous ways.

We would like to thank Chris Dercon, former director, Tate Modern whose contribution was invaluable to the development of the project. Princess Alia Al-Senussi also supported this project from its early stages. Encounters with many others enriched our research and shaped our thinking. In particular we would like to acknowledge Öner Kocabeyoğlu, Olgaç Artam, Sara Koral Aykal, Yahşi Baraz, Ali Kerim Bilge, Banu and Hakan Çarmıklı, Maria Devrim, Haldun Dostoğlu, İzi Hekimoğlu, Duygu Hoşgör, Idil Ilkin, Huma Kabakçı, Olivier Lorquin, Beral Madra, Recai Özbir, Hazer Özil, Janset Shami, Hind Sherif Nasser, Ömer Taviloğlu and Murat Ülker, as well as those who wish to remain anonymous. We would also like to thank the staff at Mathaf: Arab Museum of Modern Art, Doha and Garanti Bank, Istanbul, who shared details of the works in their collections with us.

At Tate Modern we wish to thank Frances Morris, Achim Borchardt-Hume, Helen Sainsbury, Matthew Gale and Rachel Kent for believing in this project and offering crucial advice and support. Registrar Caroline McCarthy has successfully managed the loan processes and complex transport arrangements with characteristic efficiency and good humour. Curatorial interns Elizabeth Shoshany Anderson and Aubree Penney have assisted with many aspects of the exhibition and publication. We are indebted to Rachel Barker and Rachel Scott who have done a tremendous job restoring the Zeid painting in Tate's collection, supported by Tate Patrons, and to Natasha Walker who has been a stalwart of this project. Other members of Tate's conservation team have also provided invaluable support, especially Jane Cane, Deborah Cane, Yunsun Choi, Karl Bush, Harriet Pearson, Annette King, Elizabeth McDonald and Elisabeth Andersson. Minnie Scott has been a wonderful collaborator on all interpretation material. Our thanks go to Tate's administrative team who have supported the exhibition, especially Neil Casey and Helen O'Malley. Phil Monk, Justina Budd and the art handling team have expertly managed the installation. Joseph Kendra and Isabella Nimmo have collaborated with us on the public programme. Emmylou Orton and Emily Bowen have worked tirelessly to support development activities. In Marketing and Press we would like to thank Priya Shemar and Sara Warsama respectively for all their hard work. We also thank our colleagues in Design, Photography, Front of House, Legal and External Relations for their contributions.

In London this exhibition has been made possible by the provision of insurance through the UK Government Indemnity Scheme. On behalf of Tate we would like to thank HM Government for providing Government Indemnity and the Department for Culture, Media and Sport and Arts Council England for arranging the indemnity.

Special thanks to Alice Chasey, Deborah Metherell and Jonas Vanbuel, as well as Jane Ace, at Tate Publishing, without whom this book would not exist. Thanks are also due to Philip Lewis for designing this beautiful catalogue. Finally, we would like to acknowledge Adila Laïdi-Hanieh, Necmi Sönmez and Sarah Wilson who have contributed their in-depth knowledge and original research to this catalogue, which we hope will go some way towards ensuring the legacy of Fahrelnissa Zeid.

Kerryn Greenberg | Vassilis Oikonomopoulos

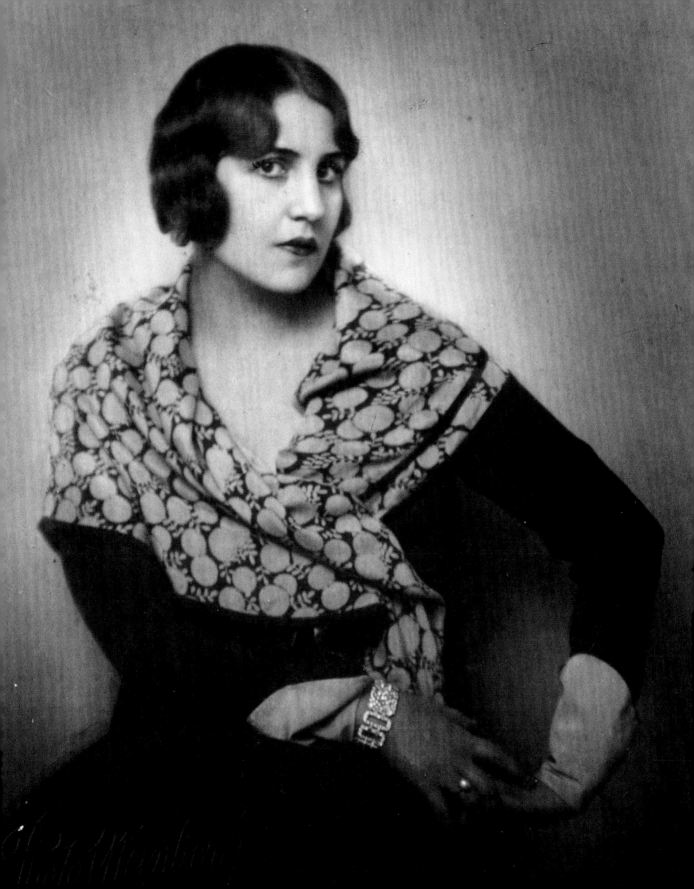

The Evolution of an Artist

KERRYN GREENBERG

Fahrünnisa Şakir (hereafter referred to as Zeid) was born into an elite and highly educated family. From humble beginnings, her uncle, Cevat Pasha, rose to prominence within the Ottoman Empire and served as Grand Vizier, the most senior ranking official, from 1891–5.[1] Cevat appointed his brother Şakir Pasha (Zeid's father) ambassador to Greece, where he met Zeid's mother Sara İsmet Hanım. By the time Zeid was born in 1901, however, her family had moved to Büyükada, the largest of the nine Princes' Islands in the Sea of Marmara, near Istanbul.[2] At the age of twelve, Zeid's world fell apart. Her father was fatally shot and her older brother, also named Cevat, was tried and convicted for his murder. That same brother had been a huge influence on Zeid, having given up his studies at Oxford University to enrol at the Academy of Fine Arts in Rome.[3] Soon thereafter the First World War broke out and Zeid's remaining male relatives were called into service. The French convent school in Istanbul that Zeid attended, and which had been her refuge after losing her father and brother and during the ensuing scandal, was forced to close.[4]

Zeid began drawing and painting at an early age, inspired by the portraits and nudes her brother Cevat made and by the still-lifes and landscapes her mother painted on silk.[5] Her earliest known surviving work is a portrait of her grandmother (fig.2), a naturalistic portrayal painted in watercolour when she was fourteen. From her teenage years onwards, art provided Zeid with an outlet through which to cope with tragedy and depression as well as being a tool to help her to find her own position in a world that was at once part of – but yet apart from – the high-society circles in which she moved. Her biography is seductive and has all the elements of drama that one might expect from fiction. Others have already recounted much of this story, however, and attention needs to be given to her artistic career.[6] Her achievements are by any standards extraordinary, although they have been somewhat forgotten since her death in 1991, particularly in London and Paris where she worked and exhibited for thirty years.[7]

Zeid's family were not immune to financial hardship and, although she was able to continue her education in Turkey during the First World War, art materials were not always easily accessible. In her memoir, Zeid's daughter recounts how her mother hand-painted postcards and sold them in order to obtain brushes, paints

FIG.1
The artist as a student at the
İnas Sanayi-i Nefise Mektebi
(Academy of Fine Arts for Women), 1920
Ömer Faruk Şerifoğlu Archive

11

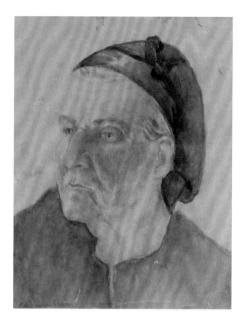

FIG.2
My Grandmother 1915
Watercolour on paper
25 × 21
The Raad Zeid Al-Hussein Collection

and notebooks as a teenager.[8] After the war, Zeid enrolled at the İnas Sanayi-i Nefise Mektebi (Academy of Fine Arts for Women) in Istanbul where the influential female painter Mihri Müşfik was director. In the early twentieth century, female Turkish painters were generally members of a privileged social class and Müşfik was no exception.[9] Fifteen years Zeid's senior, she had spent time in Rome and Paris before returning to Istanbul in 1913 where she associated with important literary and artistic figures and became known for her portraits of famous personalities. Although Müşfik and Zeid's paths would have crossed only briefly, this encounter is likely to have had an important impact on Zeid for whom there were few female role models at that time.

In 1920, at the age of nineteen, Zeid married İzzet Melih Devrim, an accomplished writer and President of the Imperial Ottoman Tobacco Company. Fourteen years older than Zeid, Devrim already had an eight-year-old daughter from a previous marriage and the household Zeid moved into was challenging.[10] For their honeymoon, Devrim took his new wife to Venice where she was exposed to European painting traditions for the first time.

Zeid's first child, a son named Faruk, was born in 1921. A second son, Nejad, and a daughter, Şirin, followed within a few years.[11] Zeid and Devrim's marriage, however, was not a happy one and it was troubled by infidelity as well as misfortune. In 1924, Faruk contracted scarlet fever from his stepsister and died suddenly.[12] In the years that followed Zeid plunged herself into the Istanbul social scene and, according to her daughter, the couple lived essentially separate lives, with trips together to Europe being the redeeming feature of their marriage.[13]

Meanwhile, political change was afoot as the Republic of Turkey was proclaimed in 1923 and Mustafa Kemal (known as Atatürk from 1934) was elected as the country's first president. The political, economic and social reforms that followed were far-reaching, and Zeid, who socialised in Atatürk's circle, was in the midst of it. A major turning point came in 1928 when Zeid travelled to Paris with Devrim who was researching the French dramatist and poet Félix-Henri Bataille.[14] While there Zeid enrolled at the Académie Ranson where she studied under the French painter Roger Bissière who was known for his unusual teaching style and charismatic personality.

FIG.3
Paul Cézanne
The Card Players 1892–5
Les joueurs de cartes
Oil paint on canvas
60 × 73
The Courtauld Gallery, London

FIG.4
Roger Bissière
Two Nudes 1927–8
Deux nus
Oil paint on canvas
46 × 38
Museum of Fine Arts
of Bordeaux

Bissière, who maintained a critical dialogue with cubism through his friendship with Georges Braque, began in the 1920s to explore earlier pictorial traditions. He was particularly inspired by Cézanne's technique of building up planes of colour through small repetitive brushstrokes.[15] Zeid's brief encounter with Bissière at this critical juncture became a defining moment in her career and, although only a few modest works have been identified from this period in Zeid's oeuvre, Cézanne's influence – synthesised and conveyed by Bissière – is still evident in the subject matter and style of some of her paintings from the early 1940s (fig.5).

On her return to Istanbul in 1929, Zeid enrolled at İstanbul Güzel Sanatlar Akademisi (Academy of Fine Arts), studying under Namık İsmail, a pupil of the French impressionists who had trained in Paris before the First World War.[16] Zeid's experience of Paris in the inter-war *années folles* (wild years), however, was very different to those of İsmail and his colleagues and she quickly became frustrated with their conservative teaching methods and left

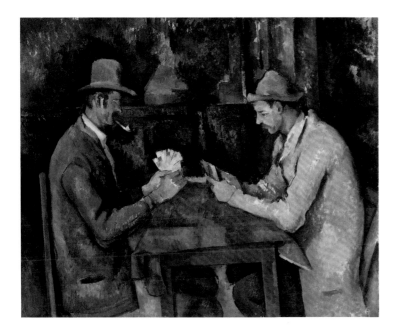

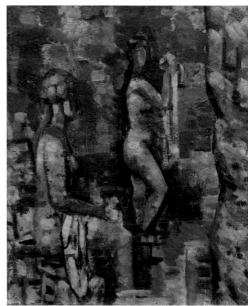

FIG.5
Yugoslav Dream 1941
Oil paint on canvas
60 × 50
The Raad Zeid Al-Hussein Collection

without completing her degree.[17] Zeid was not alone. Turkish artists and intellectuals had long travelled to Western Europe to study, but this practice accelerated after Turkey was declared a Republic in 1923.[18] Those that returned to Istanbul from 1927 onwards brought with them new techniques and an intimate knowledge of European artistic innovations and discourses, in particular the cubist and constructivist style of André Lhote and Fernand Léger's determination to depict and create art for the common man.[19] This was in direct opposition to the academic impressionism of the previous generation in Turkey.

In the early years of the Republic there was a general rejection of Ottoman art, but no single comprehensive style emerged in its place.[20] Rather, this period was characterised by the coexistence of two groups of artists. Müstakil Ressamlar ve Heykeltiraşlar Birliği (the Society of Independent Painters and Sculptors) was founded in 1929 and aimed to protect the rights and interests of its members, in particular criticising the activities of the country's arts establishment and pressing for greater official support. The second organisation was the smaller and more informal d Grubu (d Group), which was formed in 1933 by six friends (Nurullah Berk, Zeki Faik İzer, Elif Naci, Cemal Tollu, Abidin Dino and Zühtü Müridoğlu) who, initially at least, rejected the past and its traditions, choosing instead to promote and experiment with new movements in Western art.[21]

In the booklet printed for the first d Group exhibition in 1933, the author and critic Peyami Safa wrote: 'the d Group is not a squad.... This is not new painting, neither European nor local, but just painting.'[22] The d Group had 'neither a president [n]or secretary, neither directors nor ... a committee, nor regulations, neither accounts nor books, nor official identity'.[23] Rather, it was an unregulated group of young artists, each pursuing their own subjects and styles, who sought to provide fresh perspectives on art and arouse public interest in painting through regular exhibitions and lectures. They were linked together simply by the act of painting and the desire to enact 'a clandestine rebellion against academicism and the earlier generation, known as the 1914 Impressionists, who had taught most of them [at the Academy of Fine Arts]'.[24] Although their teachers had also largely studied in Paris, the First World War had curtailed

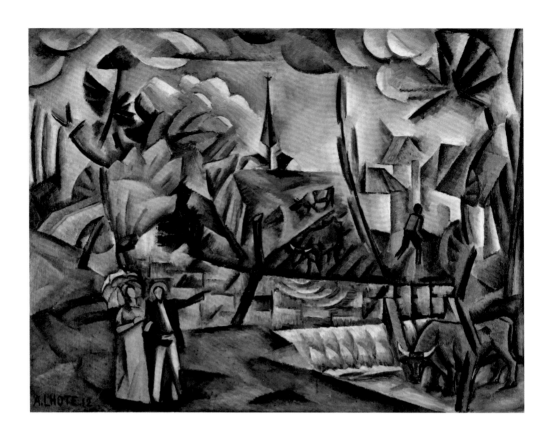

FIG.6
André Lhote
French Landscape 1912
Paysage français
Oil paint on canvas
89 × 116
Musée des Beaux-Arts
de Bordeaux

FIG.7
Nurullah Berk
**Still Life with Playing
Cards** 1933
Oil paint on canvas
64.5 × 80
Istanbul Museum of
Painting and Sculpture

their experiences of international art developments, and, according to the Turkish artist Adnan Çoker, 'they never went abroad again, they had no books, nothing'.[25]

In the beginning, the objectives of the d Group were closely aligned with the state's programme of modernisation, which, under Atatürk, looked to the West and all its institutions for inspiration. In a speech delivered on 29 October 1933, Atatürk emphasised the important role of art in restructuring the country and, as the state's populist and nationalist agenda gained momentum, so too did the d Group, holding six exhibitions in the first three years of its existence.[26]

Although Zeid would likely have been aware of these developments, she did not directly engage with them until much later. By 1934 her marriage to Devrim had disintegrated and the couple divorced, enabling the artist to marry Prince Zeid Al-Hussein (youngest son of Hussein ibn Ali al-Hashimi, Sharif and Emir of Mecca) shortly thereafter. The newly married couple moved to a villa in Büyükdere, a fashionable area on the European side of Istanbul, where Zeid spent her days painting (although she did not begin to exhibit her work until the mid-1940s).[27] Prince Zeid Al-Hussein was appointed the first Ambassador of the Kingdom of Iraq to Germany in 1935, and Zeid naturally had less time to devote to her artistic practice, which explains the lack of material in existence from this period.[28] In Berlin she had a particular role to play as the ambassador's wife and had to establish her social standing by attending and hosting numerous events. Residing in Europe, however, opened up further opportunities for Zeid to travel and immerse herself in some of the best art collections in the world.

Meanwhile in Turkey, by 1937 most of the members of the d Group had begun teaching at the Academy of Fine Arts and were becoming increasingly influential in the state's visual arts policy.[29] Members of the d Group were active as writers as well as artists and consequently carried a great deal of influence. Unlike many of their contemporaries, they wrote in French, which meant their ideas could be more widely circulated, and they had access to the media through Elif Naci, an animator associated with the group, who acted as their 'minister of propaganda'.[30]

After Hitler annexed Austria in March 1938, Prince Zeid Al-Hussein and his family were recalled to Iraq. The time Zeid spent there marked a turning point in her art practice. She was well-travelled by then, but the first time she flew in an aeroplane was over Baghdad in King Ghazi bin Faisal's plane,[31] an experience which she later attributed to playing an important role in her development as an artist:

> I did not 'intend' to become an abstract painter; I was a person working very conventionally with forms and values. But flying by plane transformed me … The world is upside down. A whole city could be held in your hand: the world seen from above.[32]

Regular trips to ancient sites such as Babylon and Nineveh also inspired her, as did seeing Bedouin women carrying produce on their heads – a subject to which she returned many times (fig.8, nos.8, 52). In an interview Zeid compared watching the Bedouin women to looking at space, speed and movement and explained that the only way to capture this was through black lines and dabs of colour.

> I later understood that I had gone back to my youth, because when I was very little, there were machicolations in front of the windows, through which one could see daylight and from which one could see passers-by … But, in fact, they were not what one saw, for they were only colours passing by and between![33]

For Zeid, the contrast between living in Berlin and Baghdad could not have been greater. In Germany she had freedom and visibility. In Iraq she encountered a segregated and conservative society, in which her movements were severely restricted.[34] She became depressed and retreated to her bedroom until a Viennese psychiatrist suggested that a change of scene would do her good.[35]

Zeid returned to Paris where she was recuperating when King Ghazi bin Faisal, (the only son of Faisal I), was killed in a car accident in April 1939.[36] Abd al-Ilah of Hejaz, the deceased king's brother-in-law assumed the regency, leaving Prince Zeid Al-Hussein, the deceased king's uncle, with no meaningful role. He moved back to Turkey, which remained neutral until shortly before the end of the war, while Zeid travelled between Paris, Budapest and Istanbul,

FIG.9
Nejad Melih Devrim
Halikarnas 1943
Oil paint on canvas
78 × 108
Lucette and Mustafa Taviloğlu Collection

attempting to immerse herself in painting and recover from her illness. Her son, Nejad, meanwhile, began studying with Léopold Lévy at the İstanbul Güzel Sanatlar Akademisi (Academy of Fine Arts), and by the time Zeid resumed working in her Büyükdere studio in 1941 Nejad was at the forefront of the Turkish art scene.[37]

Perhaps spurred on by her son, with whom she later developed an intense rivalry, Zeid was beginning to hit her stride as an artist by 1943. This was a particularly productive year and her growing confidence can not only be seen in the large-scale works *Three Ways of Living (War)* 1943 (no.12) and *Third-class Passengers* 1943 (no.6),

but also in smaller, more detailed paintings such as *My Summer House, Büyükdere* 1943 (no.3). Her subject matter at this time was varied and ranged from interior scenes and still-lifes to portraits and landscapes. She also made a number of nudes, which are evident in installation shots from her first and second solo exhibitions in Istanbul, although there are only a few extant examples such as *Nude* 1944 (fig.10). It is worth noting that while the often-cited opposition in Islam to the depiction of human and animal forms is true for religious art and architecture, in the secular sphere, such representations have flourished in nearly all Islamic cultures,[38] and Zeid and her contemporaries would have been trained in life drawing.

Zeid's penchant for vibrant colour and the importance of the black line – which are both signature aspects of her later style – are evident in most of her works from this period, most notably in *Turkish Bath* 1943 (no.7). It was at this prolific moment that the writer and art critic Fikret Adil (who had married Zeid's stepdaughter from her first marriage) saw her work and introduced her to several leading intellectuals, including those associated with the d Group.[39]

From 1933 to 1936, the d Group had been through a period of rebellion, railing against the 'old' and attempting to establish foundations for the 'new'. Most of the founding members of the d Group had either trained under André Lhote or embraced a similar doctrine, and 'were experimenting with a new form of seeing and composition based on the formal language of cubism', focussing more on technique than subject.[40] The appointments of Léopold Lévy and Rudolf Belling in 1936 as heads of the painting and sculpture departments respectively at the Academy of Fine Arts and the appointment of Suut Kemal Yetkin as Director of Fine Arts in 1939 validated the d Group's approach and, according to the Turkish art historian Zeynep Yasa Yaman, 'resulted in complete accord in the fine arts policy of the academy and the state from then on'.[41]

Zeid began to exhibit with the d Group in 1944, but by this time its character had changed considerably and the group was no longer about young artists taking a radical position. In general, members continued to eschew the possibility of a 'national art' although some sought to capture a beauty particular to Turkish culture in order to achieve originality.[42] The Second World War was still raging

THE EVOLUTION OF AN ARTIST

and opportunities to leave Istanbul were limited, but Zeid's health improved and she finally settled.[43] Photographs of exhibitions from this period, and the number of drawings of everyday scenes in Istanbul that have surfaced in recent years, indicate that she was prolific at this time. Unlike other members of the d Group, however, Zeid was not politically engaged.[44] Nor did she produce paintings that adhered to cubist principles like many of the other d Group artists. She did however share their 'enthusiasm for an art that would no longer appeal exclusively to the … bourgeoisie' and claimed to attach 'as much importance to the critical remarks of illiterate workers as to opinions expressed by sophisticated intellectuals'.[45]

Although Zeid's affiliation with the d Group was short-lived, it gave her the confidence to exhibit her work, and in 1945 she cleared out the parlour rooms of her apartment in the Maçka district of Istanbul and held her first solo exhibition.[46] When the Second World War ended members of the d Group attempted reintegration with the Western art milieu and several of the most accomplished Turkish artists moved to Europe, including Zeid's son, Nejad.[47] In 1946, after two further solo exhibitions, in Izmir in 1945 and Istanbul in 1946, Zeid relocated to London when Prince Zeid Al-Hussein became the first Ambassador of the Kingdom of Iraq to the Court of St James's.

Despite many diplomatic obligations and social engagements in London Zeid continued to paint, transforming a former maid's quarters on the third floor of the embassy into her studio.[48] Although technically based in London, Zeid's sights were set on Paris and it was not long before she rented a studio near the Jardin du Luxembourg and began to divide her time between the two cities. While she had achieved recognition in Turkey, in an interview years later Zeid recounted how she began to feel at 'ease as a painter' only after leaving Istanbul:

As long as I had lived and worked in Turkey, I had seemed to distrust my own artistic initiatives. I was too isolated, too unsure of myself. Now I feel that I am at least understood and accepted, whether in London or in Paris, as an artist rather than as a kind of freak, I mean as … a lady of the Turkish feudal nobility who

has thrown her *yashmak* [veil] over the nearest windmill and set her heart, Allah alone knows why, on becoming the first woman painter of her country much as other emancipated women of her generation have become politicians, physicians or lawyers.[49]

In post-war Paris, abstraction was taking hold as artists sought to 'wrench painting away from academic methods and from intellectual speculations, and to return to plain truths'.[50] Zeid was quickly swept up in this movement and her style rapidly shifted towards a unique form of abstraction, which drew on the specificities of her cultural background and her exposure to European art history and contemporary art discourse (see Oikonomopoulos, pp.45–56).

Although she first exhibited in London, at Saint George's Gallery in 1948 and had a significant career in the United Kingdom, it was in Paris that she felt most at home and enjoyed the recognition of some of the most important gallerists, curators and critics of the time (see Wilson, pp.89–101).

Her position as a member of the Iraqi royal family and as the ambassador's wife undoubtedly opened doors for her, particularly in London where she was a complete newcomer. While members of high society attended her exhibition openings, however, the art world also took note and her work received many favourable reviews. Maurice Collis was one of the critics in London who reviewed her exhibition at Saint George's Gallery and subsequently became a close friend. It was Collis who suggested that Zeid host salon evenings at the embassy in order to gather about her the artists and intellectuals of the capital.[51] Over the next decade, while living between London and Paris, Zeid made her strongest works: monumental abstract canvases that submerge the viewer in a kaleidoscopic universe that is simultaneously familiar and disorientating. The influences of nature, patterns from Islamic architecture, Byzantine mosaics and the formal qualities of stained-glass windows with their heavy leaded lines and iridescent coloured panels can all be discerned. Seen from a distance, these elements appear to spin, collide, fragment, repeat and ripple out from numerous centres in ways that are absorbing and mystifying.

The prominent French art critic and curator Charles Estienne became a major proponent of Zeid's work, including her paintings in significant exhibitions such as *Peintres de la Nouvelle École de Paris* in 1952. Meanwhile Zeid also participated in the annual Salon des Réalités Nouvelles at the Musée des Beaux-Arts de la Ville de Paris as well as showing in numerous commercial galleries in Paris. Of these, the most noted was an exhibition at Galerie Dina Vierny in 1953, in which Zeid presented her recent abstract paintings including *The Octopus of Triton* 1953 (fig.25) and *Sargasso Sea* 1953 (fig.27). This exhibition travelled, more or less wholesale, to the Institute of Contemporary Arts in London in 1954.

In the mid-1950s Zeid was at the height of her career, working on a scale few other women artists had attempted and which had little in common with the traditional miniatures of Turkish, Persian or Moghul art, influences that are more discernible in her early paintings.[52] Her determination and zeal is evident in her crowded compositions, hasty brushwork and photographs of the crammed studios in which she worked. Unstretched canvases filled the walls from floor to ceiling and in some instances wrapped around the corners of the studio. Other paintings were nailed directly to the ceiling and painted stones were carefully arranged on any available surface. Zeid was immersed in an environment of her own creation.

In 1958, Zeid's world was shattered again. That summer, after convincing her husband not to return to Baghdad as acting regent while his great nephew, King Faisal II, who had now ascended to the throne, went on vacation, the couple went to their holiday home on the island of Ischia in the Bay of Naples. On 14 July 1958 there was a military coup d'état in Iraq and the entire royal family was assassinated. While Prince Zeid Al-Hussein and his wife fortunately escaped death, they were given only twenty-four hours to vacate the embassy.[53] The coup abruptly halted Zeid's career as a painter and hostess in London.[54] A few years later she said:

I no longer feel any magic in it, any enchantment around me or within me. It is as if I had suddenly become afraid of colours and of life. Instead of the brilliant kaleidoscope that once seemed

to surround me, I can only perceive, all around me, a winding labyrinth of hard and heavy black lines. I feel lost among them, unable to emerge from the maze of my sorrow and my mourning …It is as if I had been brutally brought back to the very start of my career as an artist and were now forced to test again the validity of every device that I have ever used.[55]

The couple moved into an apartment in London and, at the age of fifty-seven, Zeid cooked her first meal,[56] an experience that prompted her to begin painting on turkey and chicken bones, which she later cast in resin and referred to as *paléokrystalos*. Ischia became a refuge for the family and Zeid's approach to life and to making art changed.[57] Inspired by the natural environment of the island, she began to move away from the strong black lines that had once underpinned her compositions and embraced a more gestural style with less defined forms and impressionistic brushwork (no.69). The natural world had always been of interest to Zeid so this was not an entirely new departure, more notable, however, was her return to portraiture.

Throughout her career Zeid made works on paper: stylised black drawings that reveal her interest in Turkish calligraphic traditions (nos.35–39); small abstract works with serpentine thin black lines and iridescent colours (nos.23–24, 45–50); lithographs (nos.40–44); and sketches of landscapes, scenes and people she wished to remember in her notebooks.[58] While she exhibited her abstract ink drawings, gouaches and lithographs alongside her paintings in the 1950s, she kept her figurative sketches private and it was only after the coup that she returned to portraiture publicly. Although Zeid's world had been turned upside down – and at the time she could not envisage a way to right it – in 1960 the American poet Édouard Roditi described this rupture as an opportunity: 'relieved of dynastic or diplomatic responsibilities, she can at last devote all her time and her boundless energy, whether in London, in Paris or on the island of Ischia, to her painting'.[59]

A few years later, her youngest son, Prince Raad, married and, at the invitation of his cousin King Hussein, moved to Amman, Jordan. Sensing her mother was becoming depressed in London, Zeid's daughter organised a mid-career survey exhibition at the İstanbul

Güzel Sanatlar Akademısı (Istanbul Academy of Fine Arts) and the Hıtıt Müzesı in Ankara, the artist's first solo exhibition in Turkey since departing for London in 1946.[60] In 1969 Zeid and her husband left London for Paris and a year later Prince Zeid Al-Hussein died. Zeid was bereft, but remained in Paris another four years, exhibiting recent portraits of her family and close friends alongside her late abstract paintings at Galerie Katia Granoff in 1972. In 1975 she relocated to Amman to join her son and his family and once there quickly set about creating a social and artistic scene to replace those she had left behind. She gathered aspiring artists around her and mentored them (see Laïdi-Hanieh, pp.131–140), all the while painting well into her eighties.

FIG.13
Zeid in her home, Amman, 1991
Yahşi Baraz Archive

Although more than twenty-five years have passed since Zeid
died and the interior of the small house she occupied in Amman has
long been dismantled and transformed into a restaurant, her legacy
lives on. Her presence there was so great and the recollections of her
friends and family so vivid, it is possible to sit in one of the gilded
Ottoman thrones, which she inherited and carried with her around
the world, close one's eyes and imagine being in her home. Her single
bed pushed into the furthest corner of the bedroom alongside a
bookshelf groaning with family photographs and correspondence,
the walls covered with her late works – painted-glass light-boxes
in ornate gilded frames – alongside small paintings, drawings and
exhibition posters she designed. The monumental painting *My Hell*
covering every inch of the far wall of her sitting room, a bright
abstract canvas leaning in front of it, other paintings hanging from
the ceiling, all jostling for space amongst the antiques, rich carpets
and heavy brocade, the *paléokrystalos* sculptures carefully illuminated
and whirling round, a table laid with gold goblets and a feast for
her friends. It is no wonder people gravitated towards her. In one
of the most unlikely places, Zeid had recreated her world.

1 In the nineteenth century, the Grand Vizier's position in the Ottoman Empire was comparable to that of a prime minister in European states.

2 Shirin Devrim, *A Turkish Tapestry: The Shakirs of Istanbul*, London 1996, p.11.

3 Ibid., p.26.

4 Ibid., p.37.

5 Ibid., pp.26–7.

6 Several people close to Zeid, including her daughter Shirin Devrim Trainer and her friend Janset Berkok Shami have written personal recollections of the artist and her history. See Shirin Devrim, *A Turkish Tapestry: The Shakirs of Istanbul* (London 1996) and Janset Berkok Shami, *Fahrelnissa and I* (Istanbul 2016). The story of Zeid's brother, Cevat Şakir, inspired the biopic *The Blue Exile* (Erden Kiral, 1993).

7 Zeid participated in a three-person exhibition, *Trois femmes peintres* with the Algerian Baya Mahieddine and Moroccan Chaïbia Talal, at Institut du monde arabe in Paris in 1990. Zeid's last solo exhibition in London was in 1957.

8 Devrim 1996, p.38.

9 Berke Inel and Burçak Inel, 'Discovering the Missing Heroines: The Role of Women Painters in Early Modernist Art in Turkey', *Middle Eastern Studies*, vol. 38, no. 2 (April 2002), p.207.

10 Devrim 1996, pp.50, 52.

11 In 1946 Şirin travelled to America to attend Barnard College, New York, and, later, Yale School of Drama, New Haven. Around this time she anglicised her name, spelling it Shirin.

12 Devrim 1996. p.61.

13 Ibid., p.68.

14 Ibid., p.75.

15 Press release accompanying the exhibition *Bissière, figure à part* at the Galerie des Beaux-Arts, Bordeaux. www.musba-bordeaux.fr/sites/musba-bordeaux.fr/files/images/rich_text/dossier_de_presse-bissiere_figure_a_part_-_bordeau_musee_beaux_arts.pdf, accessed 8 February 2017.

16 In September 1926 the İnas Sanayi-i Nefise Mektebi (Academy of Fine Arts for Women) merged with the İstanbul Güzel Sanatlar Akademisi (Academy of Fine Arts, Istanbul).

17 My thanks to Necmi Sönmez for this detail.

18 'Adnan Çoker'le Söyleşi in conversation with Zeynep Yasa Yaman', in Nihal Elvan (ed.), *d Grubu 1933–1951*, exh. cat., Istanbul Museum of Painting and Sculpture and Yapı Kredi Kâzım Taşkent Art Gallery, Istanbul 2004, p.52.

19 Zeynep Yasa Yaman, 'd Grubu 1933–1951', in Nihal Elvan (ed.), 2004, p.7.

20 'Art and Nationalism in Twentieth-Century Turkey', *Heilbrunn Timeline of Art History*, www.metmuseum.org/toah/hd/anrt/hd_anrt.htm, accessed 1 March 2016.

21 Yasa Yaman 2004, p.8.

22 Ibid., p.9.

23 Elif Naci 'd Grupu', *Yeni İnsan*, 11, 7, 1964, p.17 quoted in Yasa Yaman 2004, p.17.

24 Yasa Yaman 2004, p.10.

25 'Adnan Çoker'le Söyleşi in conversation with Zeynep Yasa Yaman', in Nihal Elvan (ed.), 2004, p.49.

26 Refik Epikma, 'Atatürk ve Sanat', *Türk Dili*, 11, 14, 1, Kasım, 1952, p.76 referred to in Yasa Yaman 2004, p.21.

27 Devrim 1996, p.92.

28 A portfolio of Zeid's early works was also purportedly stolen while she was on a train. André Parinaud (ed.), *Fahrelnissa Zeid*, Amman 1984, p.26.

29 Yasa Yaman 2004, p.8.

30 'Adnan Çoker'le Söyleşi in conversation with Zeynep Yasa Yaman', in Nihal Elvan (ed.), 2004, p.60.

31 Devrim 1996, p.127.

32 Parinaud (ed.), 1984, p.38.

33 Ibid.

34 Devrim 1996, p.127.

35 Ibid., p.134.

36 Charles Tripp, *A History of Iraq*, Cambridge 2000, p.98.

37 Cem İleri (ed.), *Fahrelnissa & Nejad: Two Generations of the Rainbow*, exh. cat., Istanbul Modern, 2006, p.76.

38 'Figural Representation in Islamic Art', *Heilbrunn Timeline of Art History*, www.metmuseum.org/toah/hd/figs/hd_figs.htm, accessed 10 January 2017.

39 Devrim 1996, p.149.

40 Yasa Yaman 2004, p.24.

41 Ibid., p.25.

42 Ibid., pp.27–8.

43 Devrim 1996, p.150.

44 Édouard Roditi, *Dialogues on Art*, London 1960, p.196.

45 Ibid.

46 Zeid participated in the eleventh, twelfth, fourteenth and fifteenth d Group exhibitions. Necmi Sonmez, 'The World of Fahr El Nissa's Art as a Model of Liberation', *Fahr El Nissa Zeid*, exh. cat., Erol Kerim Aksoy Foundation, Istanbul 1994, p.30. Her first solo exhibition is frequently listed as having occurred in 1944. However, original invitation cards and leaflets from her exhibitions in her apartment in Istanbul are dated 14–24 April 1945 and 11–31 May 1946.

47 Yasa Yaman 2004, pp.28–9.

48 Devrim 1996, p.167.

49 Roditi 1960, p.196.

50 Parinaud 1984, p.21.

51 Maurice Collis, *Journey Up: Reminiscences 1934–1968*, London 1970, p.102.

52 Roditi 1960, p.189.

53 Devrim 1996, p.210.

54 Collis 1970, p.105.

55 Roditi 1960, p.190.

56 Devrim 1996, p.210.

57 Ibid., p.215.

58 When asked about the influence of calligraphy on her practice, Zeid replied: 'The Turkish calligraphers of the past, in their directly creative attack on empty space, have formulated a style of abstraction that is almost the same as that of the Western action painters of today.' Roditi 1960, p.193.

59 Ibid., p.190.

60 Devrim 1996, p.218.

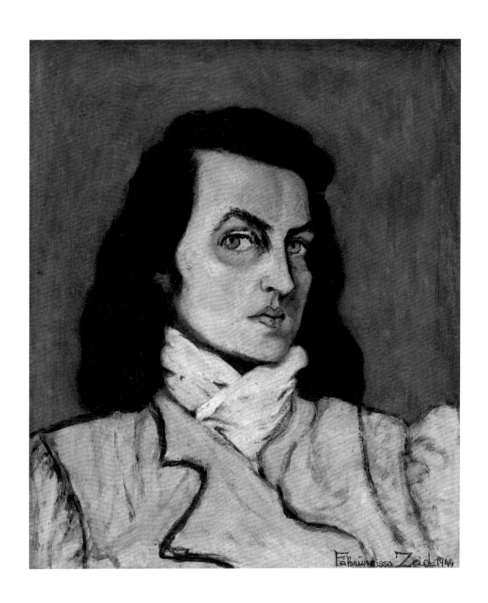

1

Self-Portrait 1944
Oil paint on canvas
60 × 50
Sema and Barbaros Çağa Collection

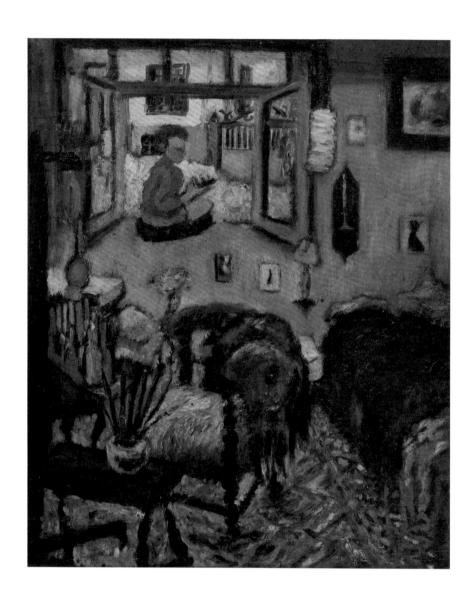

2
Beshiktas, my Studio 1943
Oil paint on canvas
58.7 × 48.8
The Raad Zeid Al-Hussein Collection

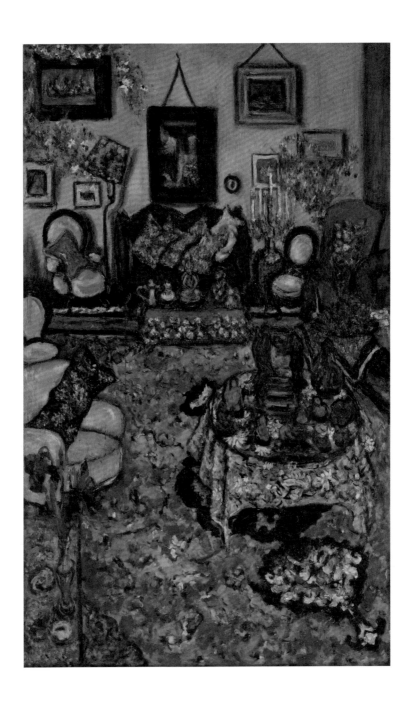

3

My Summer House, Büyükdere 1943
Oil paint on plywood
76 × 47.5
The Raad Zeid Al-Hussein Collection

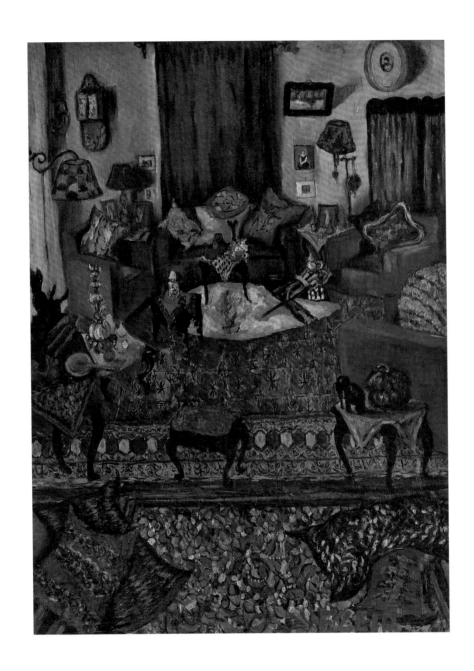

4

My Winter Flat in Istanbul 1943
Oil paint on plywood
72 × 55
The Raad Zeid Al-Hussein Collection

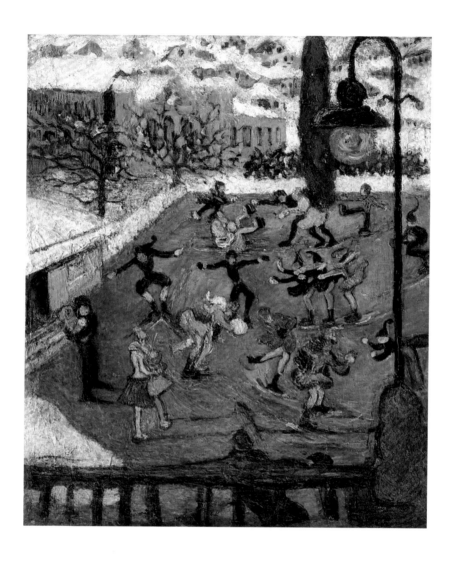

5
**Budapest, the Express between
Budapest and Istanbul** 1943
Oil paint on canvas
55 × 47
Private collection

6
Third-class Passengers 1943
Oil paint on plywood
130 × 100
Istanbul Museum of Modern Art Collection
Eczacıbaşı Group Donation

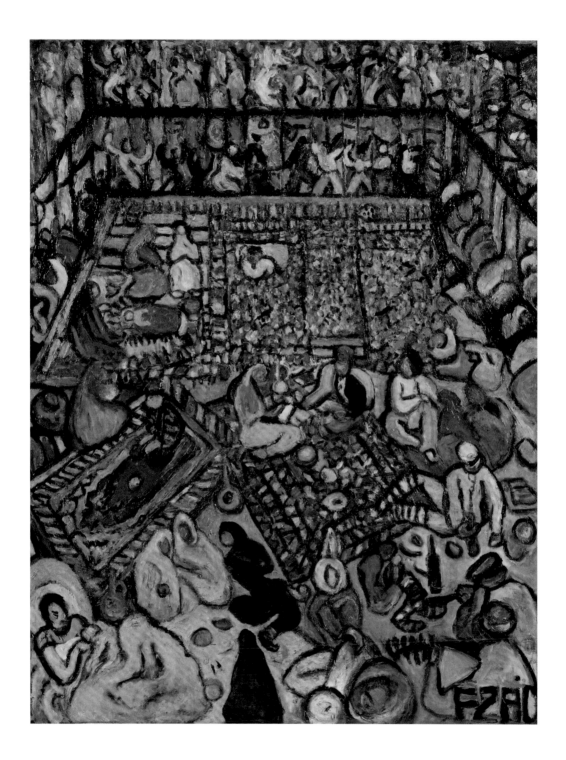

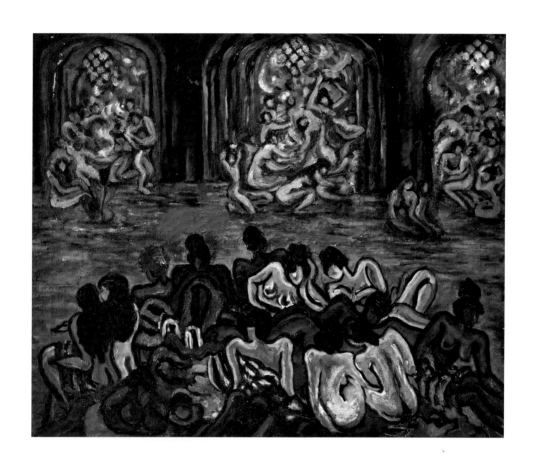

7
Turkish Bath 1943
Oil paint on canvas
51.5 × 63.2
The Raad Zeid Al-Hussein Collection

8
Bedouins Selling Yoghurt 1949
Bédouines vendant des yaourts
Oil paint on plywood
48 × 70
Musée de l'Institut du monde arabe

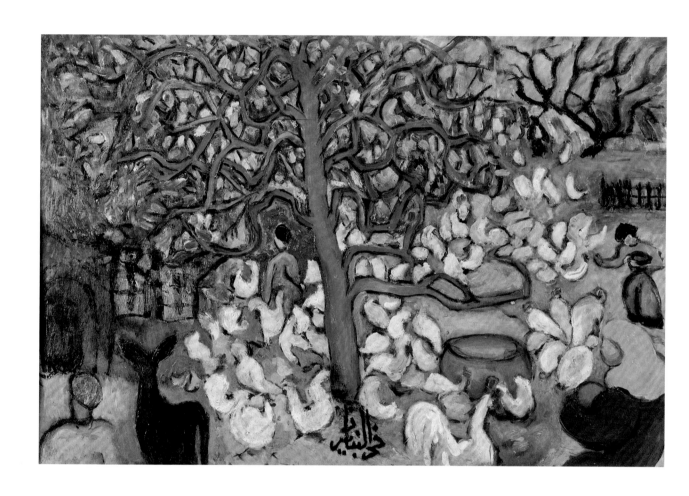

9
**Polonezköy (Polish Village
on the Bosphorus)** 1944
Oil paint on plywood
59 × 91
Çela and Nazif Aktaş

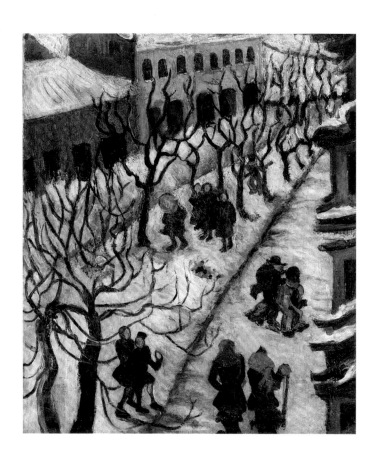

10

A Winter Day, Istanbul c.1944
Oil paint on canvas
55 × 47
Private collection

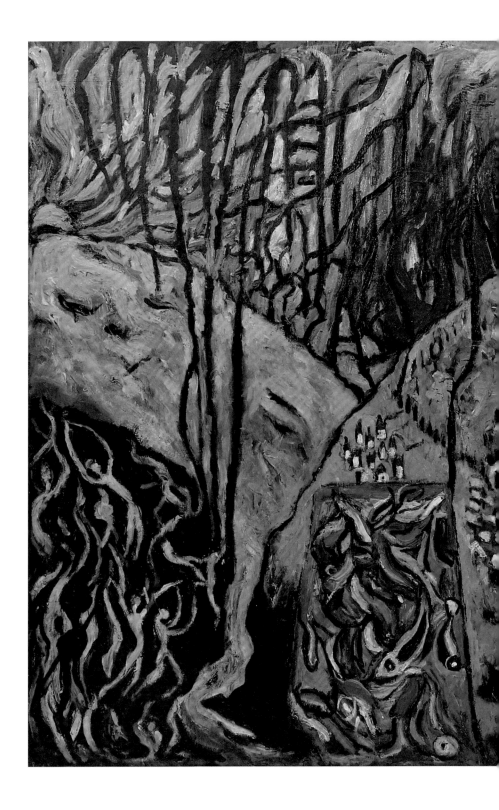

11
**Three Moments in a Day
and a Life** 1944
Oil paint on plywood
125 × 209
The Raad Zeid Al-Hussein Collection

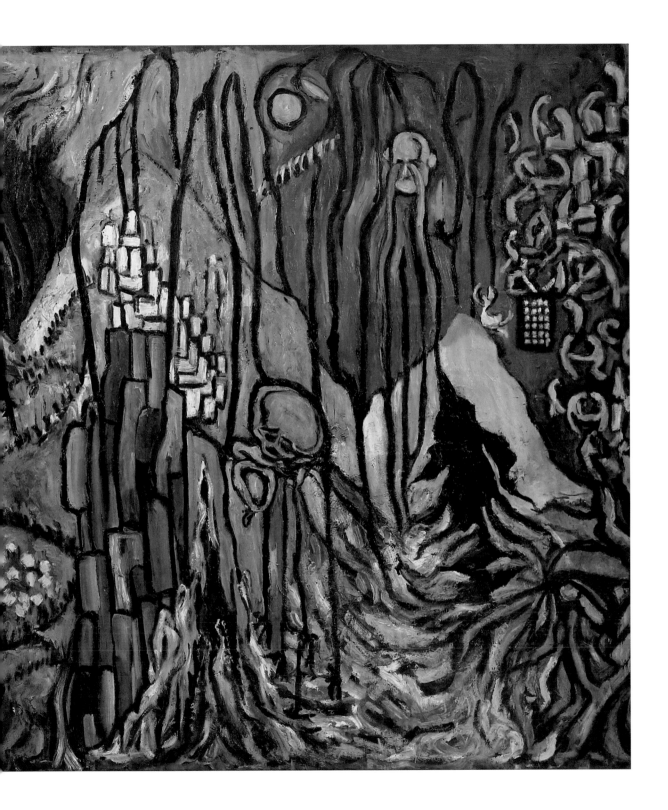

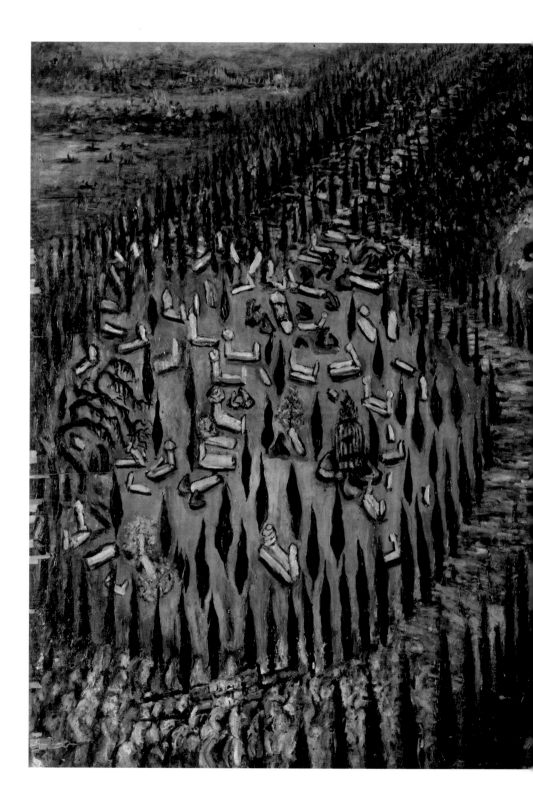

12
Three Ways of Living (War)
1943
Oil paint on plywood
125 × 205
Ela Sefer
(Photographed prior to restoration)

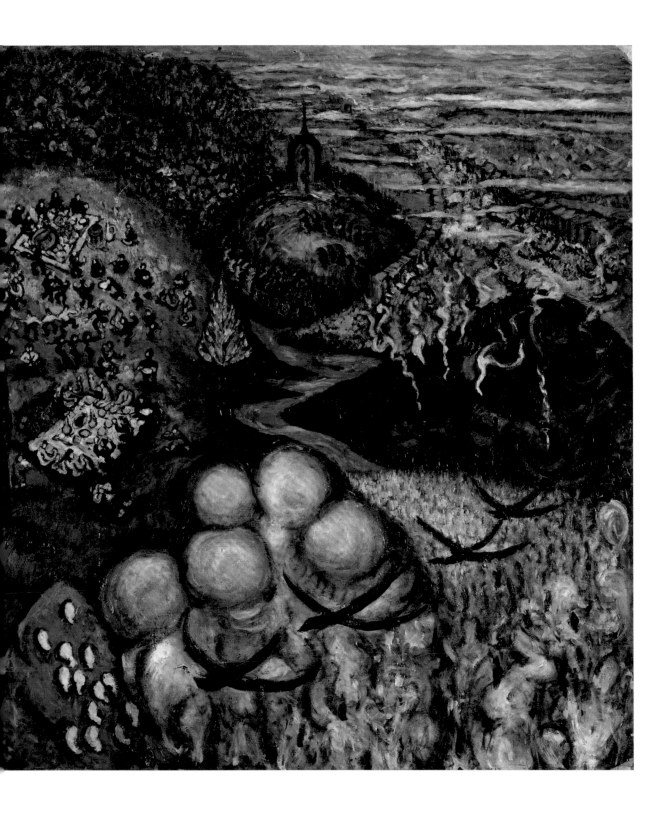

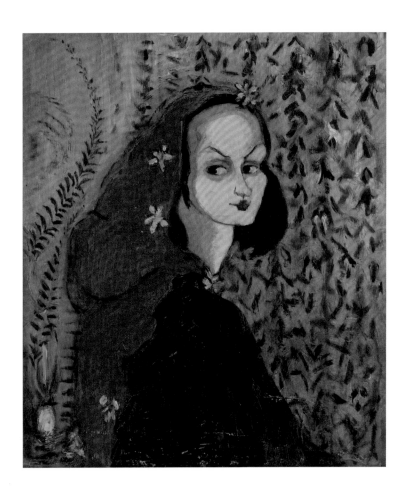

13
Untitled before 1946
Oil paint on plywood
49 × 43
The Raad Zeid Al-Hussein Collection

14
Emir Zeid 1944
Oil paint on canvas
68 × 57.5
The Raad Zeid Al-Hussein Collection

> I am a descendent of four civilisations. In my self-portrait
> [*Someone from the Past* 1980], the hand is Persian, the dress
> is Byzantine, the face is Cretan and the eyes Oriental, but
> I was not aware of this as I was painting it.
>
> FAHRELNISSA ZEID[1]

Multiple Dimensions of a Cosmopolitan Modernist

VASSILIS OIKONOMOPOULOS

Fahrelnissa Zeid's reflections on identity and art resonated throughout her practice and life. Examining the late self-portrait referred to above (fig.15), Zeid observed a complex amalgam of cultural traditions and diverse histories. For Zeid, painting enabled these elements to surface from her subconscious and occupy the picture plane. Having completed her self-portrait, and with the benefit of hindsight, the artist was able to recognise the multifaceted aspects of her own character – the Persian, Byzantine, Cretan and Oriental traces – that shaped her sense of self and place in an ever-shifting world and provided her with a unique combination of influences to draw upon.

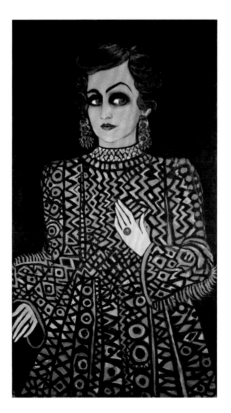

FIG.15
Someone from the Past
1980
Oil paint on canvas
210 × 116
The Raad Zeid
Al-Hussein Collection

FIG.14
Zeid, Paris, early 1950s
Tate Archive

In her paintings, Zeid appropriated modernist concepts, techniques and styles and infused these with principles distilled from Eastern and Oriental traditions and the cultures that informed her own complex identity. Like many action painters working in the 1950s and 1960s, Zeid was aware of an inner creative energy, but, as Édouard Roditi (the poet, essayist and translator associated with the surrealists) noted at the time, she was generally 'content to remain an instrument of this turmoil, without seeking to understand or to master it'.[2] Nevertheless, the analogies and anecdotes she frequently used to describe her process reveal the range of contradictions and histories within her, which stimulated the development of her singular vision.

Zeid began drawing and painting at a very early age.[3] However, it was only in the mid-1940s, in middle age, that she decided to dedicate herself to her art and began exhibiting her work. Up until then, making art had been a private activity and Zeid had predominantly focused on expanding her artistic education, which led her to, among other places, the Académie Ranson in Paris, which she attended in 1928.

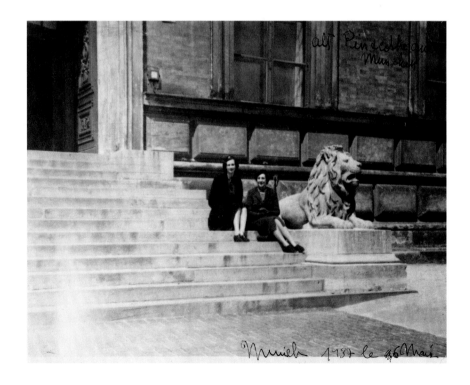

FIG.16
Zeid outside the Alte
Pinakothek, Munich, 1937
The Raad Zeid
Al-Hussein Collection

Although Zeid spent only a short time at the academy, her experience there had a lasting impact. Under the tutelage of French painter Roger Bissière, her thinking transformed and she became more open and receptive. Later in life, when discussing portraiture, she stated:

> The portrait is not only a figure, it is not an image, it is not an exterior, it is not an envelope, it is not a colour, it is not a form … It is much more than these. It is love. It is pure spirit. My professor, the painter Bissière[,] had explained it to me in this way. It was my second week at the Academy where he was teaching and I didn't even know yet how to mix colours.[4]

The idea of expanding the understanding of the figure while including elements of spiritual energy in painting would later become a systematic methodology for Zeid.

Concepts widely circulating in England and on the Continent in the inter-war and post-war periods – in particular, in the art scenes in Paris and London – played a significant role in Zeid's trajectory. While engaged in the contemporary moment, the artist was also significantly influenced by European art history. In the 1920s, in addition to studying in Paris, Zeid had visited Venice and admired Italian Renaissance art, local painting traditions, religious iconography, sculpture and architecture. By the mid-1930s, when she moved to Berlin, she was well-travelled and had visited numerous European museums, absorbing the rich art collections and studying the techniques of the old masters.

The Dutch Renaissance painters in particular fascinated Zeid, and the influences of Jan Brueghel and Pieter Bruegel the Elder, with their representations of everyday life and complex compositions describing the intensity of human activity, are evident in her paintings from the early 1940s.[5] At this time, Zeid was living and working in Istanbul and was affiliated with the avant-garde, progressive movement of artists called the d Group. Her most accomplished paintings from this period tend to be portraits and populated landscapes and interior scenes, which in subject and composition reveal the influence of the Renaissance masters. This is especially evident in works such as *A Winter Day, Istanbul* c.1944 (no.10) and *Polonezköy (Polish Village on the Bosphorus)* 1944 (no.9).

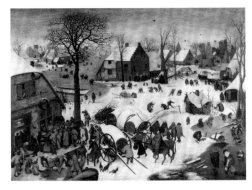

FIG.17
Pieter Bruegel the Elder
Census at Bethlehem 1566
Oil paint on panel
115.5 × 163.5
Royal Museums of Fine Arts
of Belgium, Brussels

During the Second World War, when opportunities to travel were limited, Zeid systematically studied Istanbul's natural scenery and topography, human presence and activity. While visits to European cities in the 1920s and 1930s had impressed her, Istanbul in the early 1940s offered other pictorial forms and traditions, to which she would return throughout the rest of her life. Even in her abstract paintings, the contrasts and contradictions of diverse points of reference, and the suggestion of a memory or a feeling of place, are always present.

Undoubtedly, this period in the mid-1940s, when she began moving towards abstraction, was one of the most significant in Zeid's career. By the late-1940s, the exploration of abstract forms began to dominate her thinking and would lead her to rapidly embrace a pictorial idiom entirely informed by non-representational imagery. A detailed investigation into some of the key works from the artist's abstract period will allow us to unravel the distinctive artistic traces and techniques that Zeid borrowed from both Eastern and Western pictorial traditions and art.

FIG.18
Istanbul n.d.
Mixed media on paper
26 × 36
Private collection

FIG.19
Seventeenth century Kutahaya and
Iznik tiles, Topkapi Palace, Istanbul

Istanbul has been the capital city of two of the world's greatest empires: the Byzantine and the Ottoman. The impact of its history is evident all over the city. The layout of Istanbul, the architecture of its mosques and palaces, the local crafts and popular art forms have all been influenced by these two civilisations. The decorative arts – the making of tiles, stained-glass windows and embroidered textiles – reveal the position of the city at the crossroads of cultures. The mixture of religions, oral traditions, poetry and literature that defined the rich cultural landscape of Istanbul became key for Zeid, who absorbed and incorporated these diverse elements into her practice.

Zeid's abstract output was heavily inspired by the geometry found in Islamic and Byzantine mosaics; the rhythm of calligraphic motifs; and the philosophies of Eastern traditions. Her abstract compositions employ a language that infuses these elements with explorations of the nature of line and the structural qualities of gestural techniques.

It is crucial to mention that Zeid relocated from Istanbul to London in 1946 and then maintained studios in both London and Paris until the late 1960s.[6] Prior to that, Zeid had travelled extensively and lived in Berlin and Baghdad. These moves influenced her artistic vision and contributed to the development of her abstract vocabulary. In Europe and Turkey Zeid enjoyed a relatively unrestricted social and artistic life. In Baghdad her movements were limited and her engagements were structured according to Iraqi cultural etiquette. Still, she continued to paint and draw with an emphasis on depictions of local customs and everyday life. Her return to Europe after the Second World War signalled a new direction for her work, as she was liberated from the conventional milieu she had encountered in Baghdad.

In London, Zeid began to progressively eliminate elements of figuration, which had been central to her practice until then, from her painting and within a few short years she had fully embraced abstraction. This metamorphosis was marked by internal tensions. The painting *Fight against Abstraction* 1947 (no.16) reveals the inner workings and psychological torment of the artist at the moment of transition. This painting is characterised by a rich geometric, spatial complexity, within which the figurative elements seem to be

relentlessly defending a domain almost overtaken in its entirety by undulating shapes, triangles and lines. The result is a disharmonious clashing of styles. *Fight against Abstraction* is a classic transitional work, which incorporates the fundamental aspects that distinguish Zeid's later abstract work: precise geometric patterns executed in carefully selected colours and delineated by black lines that allude to the history of mosaic art and stained-glass windows. In this painting, Zeid uses a combination of pale and bold colours to express her inner conflict between representation and abstraction. Meanwhile, stylised figurative elements echo ancient Mesopotamian art and the tinting and shading of the hand and forearm at the centre of the work contrast sharply with flattened abstract shapes. Zeid moves between anthropomorphic descriptions and an explosion of abstract designs, carefully combining patterns and lines with a more sculptural, three-dimensional kind of painting. This is a turning point in her career – a distillation and simultaneous exploration of figuration and abstraction.

A year later, Zeid visited Loch Lomond, in the Scottish Highlands. There she was captivated by a local festival occurring on the banks of the lake. In a quasi-expressionistic composition titled *Loch Lomond* 1948 (no.15) Zeid attempted to capture the bustling scene of the lakeside campsite in a palette of blues, greens and reds. The overall composition of this painting and the scene it depicts recall several earlier works painted in Istanbul, such as *Third-class Passengers* 1943 (no.6) and *Three Ways of Living (War)* 1943 (no.12). While her training in figuration and the influences of impressionism are evident in this painting, it also demonstrates Zeid's growing interest in abstract references – particularly the ways nature can be represented in miniature, fractal-like details. Zeid is less attentive to the details of the scene than to the atmosphere she detects: brightly-coloured hills merge with the vivid green that covers the centre of the composition, ultimately turning bodies, tents and hills into a multi-tonal, densely geometrical image dominated by lozenges and triangles. Like *Fight against Abstraction*, although stylistically distinct, *Loch Lomond* antici-pates Zeid's later explorations. The dynamism of the figurative aspect counteracts the lively interplay of abstract elements and defines a process of transformation whereby the figures, the landscape, the

lines and colours achieve a sense of harmony. *Loch Lomond* seems
to encapsulate the refracted light as seen through a stained-glass
window, though in an intensified, expansive manner.

Tents, Scotland 1948 (no.17) explores a similar subject on a smaller
scale. Zeid zooms in on the temporary structures, emphasising the
triangular shapes of the tents and surrounding mountains with
simple interwoven patterns and bold black lines. The painting
carries a calm energy, amplified by the use of a warm colour palette.
The triangular forms progressively become smaller, before merging
into a kaleidoscope of colour in the upper-right corner of the painting.
In this and later paintings, Zeid's emphasis on geometry and repetition
can clearly be linked to Islamic decorative motifs.

The ideas explored in paintings from 1947 and 1948 culminate
in *Resolved Problems* 1948 (no.22), which, although small, incorporates
a refined understanding of an abstract syntax, reminiscent of the
energy compressed in the composition of mosaics. By the end of
1948, it is evident that Zeid has established her independent style.

At the time, Turkish art critic Bülent Ecevit (who later became
Prime Minister of Turkey) related Zeid's paintings to her cosmopolitan
lifestyle and referred to an affiliation between nostalgia and Zeid's
work. According to Ecevit, Zeid's approach to abstract art was
informed by her experiences of mosaics 'and the result was a type
of abstract art that did not exclude human and natural elements'.[7]
It was the same spirit, the critic claimed, that had inspired mystic
poets in Anatolia through the ages; he argued that this new style
helped Zeid paint philosophical themes, thus allowing the merging
of plastic qualities and subject matter without leading to conflict.[8]
His approach in speaking of the creative process in terms of Eastern
esoteric traditions and philosophy echoes Zeid's own inclination.

If the genealogy of Zeid's abstract painting can be traced back to
her nomadic life and the intensity of her personal experiences, and to
her fascination with mysticism and philosophy, as Ecevit suggests, it
certainly gained momentum while Zeid was based between London
and Paris. It was a period fuelled by her explosive imagination and
the adaptation of abstract ideas within her work. After her initial
experiments with abstraction, Zeid consciously turned inwards,
looking at herself and her own personal history. This strategy

enabled her to find her voice and steer her own course among a constellation of other evolving practices. Zeid flourished in this moment, becoming increasingly inventive and confident and attracting the attention of influential critics, curators and dealers.

Zeid had fully embraced abstraction by the late 1940s and completed the monumental painting *My Hell* in 1951 (no.31), which is arguably the artist's masterpiece. In this work, Zeid explored the spatial possibilities offered by the surface of the canvas in unparalleled complexity, turning repetition and interlocking forms into a key organisational and methodological principle. In photographic documentation from the time, it is evident that *My Hell* was executed outside the conventions of traditional easel painting. To handle the width and length of the canvas, Zeid tacked it, unstretched, to two walls across the corner of her studio. Working on the painting in this way, the artist would have been surrounded by the composition – a necessity of sorts but also a testament to her desire to achieve an encounter with painting, not as a two-dimensional space, but as an all-encompassing environment. The pictorial qualities of the work and its experience as a spatial construct suggest Zeid's identification with the richly abstract, creative expression found in Islamic architecture, particularly the ways in which different natural and geometric motifs occupy space and expand the experience of it in these traditions.

Geometry in Islamic art and architecture was and continues to be used to expand the sense of space and vision. Consisting of, or generated from, simple forms, shapes in Islamic art are combined, duplicated, interlaced and arranged in intricate combinations. Indeed, geometric ornamentation in Islamic art reveals a remarkable amount of freedom; in its repetition and complexity, it offers the possibility of infinite growth and can accommodate the incorporation of other types of ornamentation as well.[9]

The way in which Zeid experimented with geometric forms, the intensity of her palette and her attention to detail suggest both a deep understanding of Islamic art and the desire to adapt its principles to her own needs. Black is the dominant colour in *My Hell*. Two black voids occupy a central position in the composition and diverse formations emanate from these two centres. From a distance,

the interlocking patterns seem to suggest an undulating wave, which expands and contracts based on one's vantage point. Furthermore, the colour palette of *My Hell* – vibrant red and yellow shapes – is reminiscent of Ottoman stained-glass windows and glass lanterns, where the dominance of black allows other colours to appear even stronger when illuminated. The effort required to produce a large, immersive painting through the combination of small, interconnected shapes also alludes to influences from miniature-painting traditions. *My Hell* emphasises the power of geometry and colour to create a particular state of mind – a state that exists precariously between order and chaos.

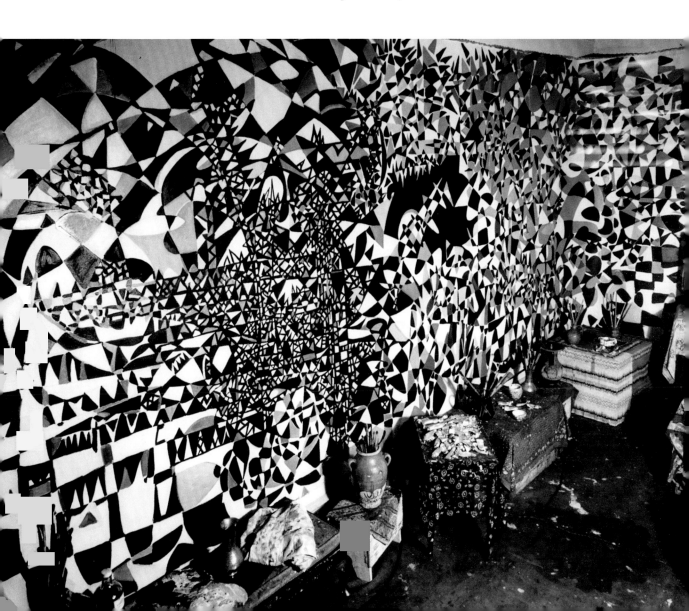

From the late-1940s, Zeid exhibited her work extensively on both sides of the English Channel. In France, she became associated with the artists and intellectuals that formed the Nouvelle École de Paris, who were loosely grouped around the figure of critic Charles Estienne. The Nouvelle École de Paris was intellectual home to a group of artists that included Maria Helena Vieira da Silva, Serge Poliakoff, Pierre Soulages and Nejad Devrim, among many others. The group came to reflect the growing and changing cosmopolitanism of Paris and played a key role in the establishment of abstract art, marking the long-awaited triumph of lyrical abstraction in the contemporary art scene (see Wilson, pp.89–101).[10]

Zeid was immensely productive in the 1950s, creating some of her best-known paintings, like *The Octopus of Triton* 1953 (no.25) and *The Arena of the Sun* 1954 (no.28), but, also, several lesser-known works like *Untitled* c.1950s (no.33), which is more restrained in palette, but still combines aspects of informal abstraction with influences drawn from mosaic and stained-glass designs inspired by Islamic and Byzantine motifs. This painting presents a web of cooler colours bound in interlocking rectangular and triangular shapes by inter-weaving lines to produce a kaleidoscopic effect. The reduced colour palette creates a sense of calm. The painting has no particular centre, but rather many centres, which seem to emanate from across the composition.

Zeid described her dynamic and spontaneous process of painting as follows:

> While painting, I find myself integrated to all living things … Then I lose myself and become a part of a superhuman creative process, which produces pictures like a volcano erupting lava and rocks. Mostly, I become aware of the picture only after it is completed.[11]

In *Untitled*, the result is a distorted and complex perspectival arrangement, characterised by repetition and ruptures. The composition resembles an explosive world or landscape suggestive of fractal geometry – lines and shapes that endlessly reverberate. In this painting, and most of Zeid's works from this period, there is an implied sense of movement. Her later decision to place her

paléokrystalos sculptures on turntables suggest a long-standing interest in motion, as does the presence of a mobile by British artist Lynn Chadwick hanging in Zeid's London living room, seen in photographs from the 1950s (fig.21).

Untitled is one of the few works the artist did not sign on the verso. It is known, from photographic documentation and anecdotes, that Zeid believed good abstract paintings need not be restricted to a single orientation. Photographs of the artist's studio and exhibition installation shots, taken during the artist's lifetime, depict paintings hanging in different orientations, and frequently in unconventional ways – sometimes nailed to the ceiling or wrapped around the corner of her studio. Her attempt to approach abstraction as an environment but also as a form that constantly evolves and changes, based on a set of initial principles, reveals that the foundational language of her

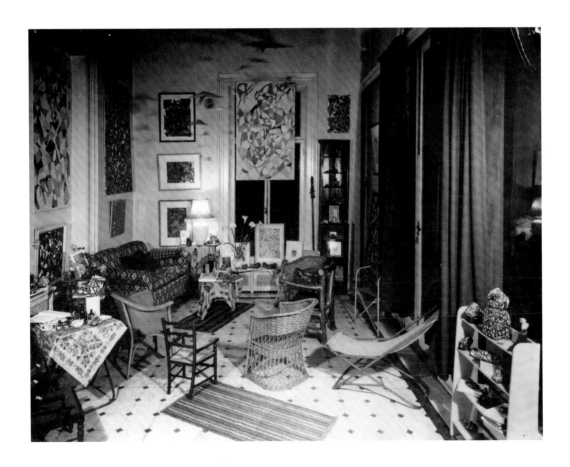

practice resides in the spiritual and philosophical underpinnings of Eastern traditions. Elements such as perpetual motion, repetitive patterns and motifs, order and expansion and the evolution of forms through structure are all concepts she embraced and tackled in her career. Zeid's approach was formulated in relation to a concept of nature as an expansive form, an abstraction of sort – an idea we cannot grasp in its entirety.

Other works that present similar analogies and which appear to address fundamental questions about abstract painting and Zeid's myriad influences include *Abstract Parrot* c.1948–9 (no.18), *Ubu Bird* ('*The Phoenix*') 1952 (no.30) and *The Octopus of Triton* 1953 (no.25). These three paintings, all inspired by and referencing animals in their titles, further question the relationships between the visible and the spiritual, nature and representation. The association of forms and shapes to the surface of the canvas, the lack of depth and the illusion of recognisable zoomorphic representation draws heavily on Zeid's experiences of the world through a multicultural prism.

Revisiting Zeid's reflection on her late self-portrait, we can see how her biography influenced the art she made. She straddled multiple divides: between East and West, but also between high society and the artistic community. She moved seamlessly between these multiple spaces, drawing on her experiences of the world and adopting and adapting various cultural traditions and artistic languages to suit her own purposes, resolving the contradictions of her own life in her art.

1 Fahrelnissa Zeid, quoted in André Parinaud (ed.), *Fahrelnissa Zeid*, Amman 1984, p.37.

2 Édouard Roditi, 'Dialogues on Art with Édouard Roditi', reprinted in Parinaud (ed.) 1984, p.156.

3 The earliest known work attributed to the artist is a portrait of Zeid's grandmother, completed in 1915 when Zeid was fourteen years old.

4 Parinaud (ed.) 1984, p.28.

5 Cem İleri (ed.), *Fahrelnissa & Nejad: Two Generations of the Rainbow*, exh. cat., Istanbul Modern, 2006, p.24.

6 Zeid left London in the spring of 1969 to live permanently in Paris. In 1975 she relocated to Amman, Jordan.

7 Bülent Ecevit, paraphrased in Cem İleri (ed.), *Fahrelnissa and Nejad: Two Generations of the Rainbow*, exh. cat., Istanbul Modern, 2006, p.43.

8 Ibid.

9 Department of Islamic Art, The Metropolitan Museum of Art, 'Geometric Patterns in Islamic Art', *Heilbrunn Timeline of Art History*, New York 2000, http://www.metmuseum.org/toah/hd/geom/hd_geom.htm, accessed 23 December 2016.

10 See Georges Mathieu, *De la révolte à la renaissance*, Paris 1973; Geneviève Bonnefoi, *Les Années Fertiles, 1940–1960*, Paris 1988.

11 Philip Mansell, 'My Life is a Serenade – Fahrelnissa Zeid (1901–1991)', *Güneş Gaz*, Istanbul 1990, p.12.

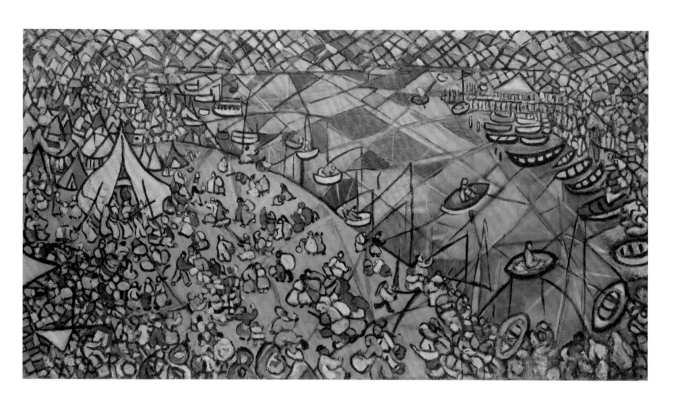

15
Loch Lomond 1948
Oil paint on canvas
102 × 192
The Raad Zeid Al-Hussein Collection

16

Fight against Abstraction 1947
Dispute contre l'Abstraction
Oil paint on canvas
101 × 151
Istanbul Museum of Modern Art Collection
Eczacıbaşı Group Donation

17
Tents, Scotland 1948
Oil paint on canvas
50 × 60.5
Istanbul Museum of Modern Art Collection
Eczacıbaşı Group Donation

18
Abstract Parrot c.1948–9
Oil paint on canvas
106 × 155.5
Istanbul Museum of Modern Art Collection
Eczacıbaşı Group Donation

19
Mosaics 1949
Oil paint on canvas
105 × 157
Private collection

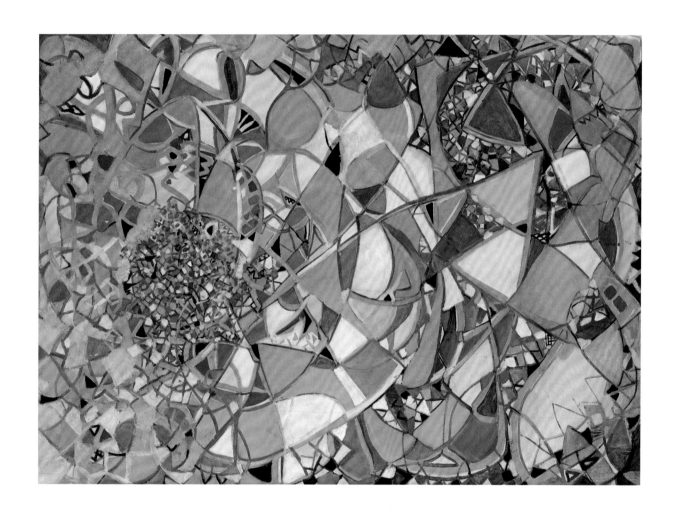

20
Mixed Stasis 1949
Oil paint on canvas
132 × 182
Sema and Barbaros Çağa Collection

21
Composition before 1950
Oil paint on canvas
188 × 175
Musée d'Art Moderne
de la Ville de Paris

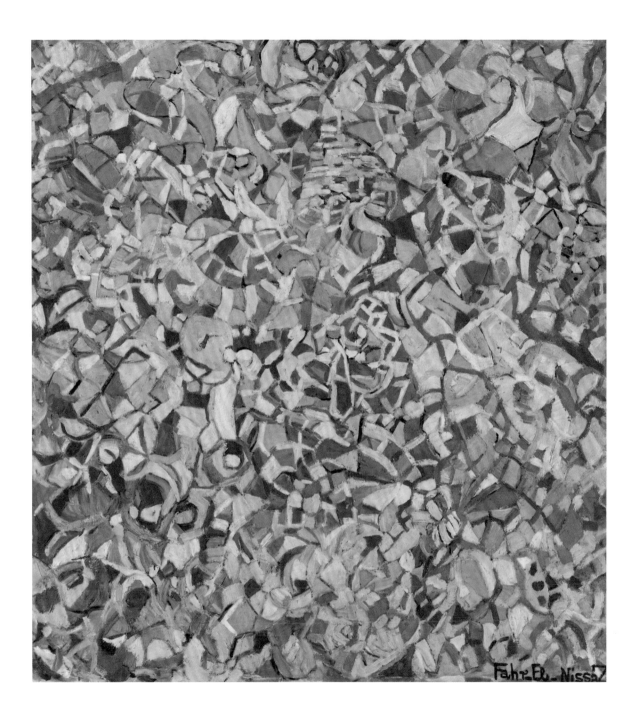

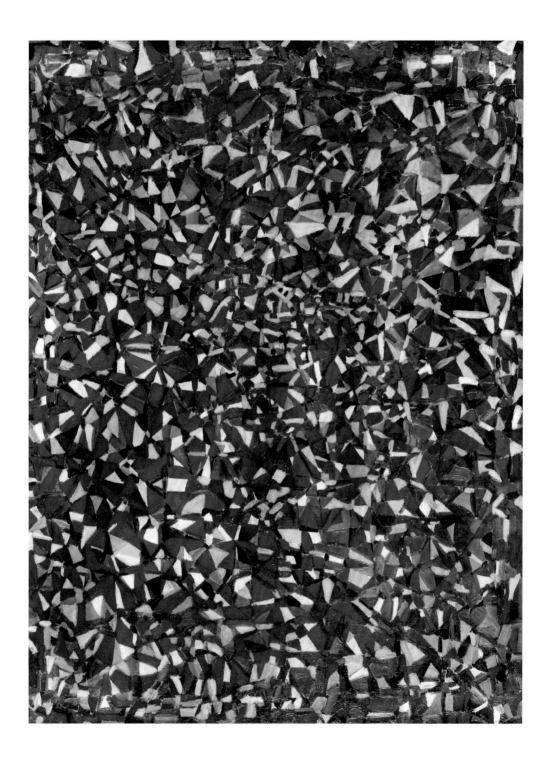

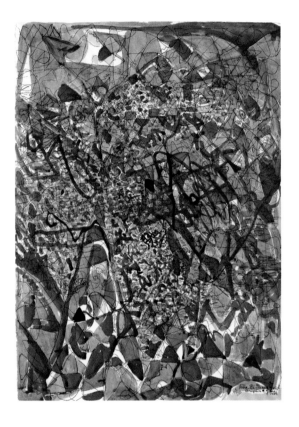

22
Resolved Problems 1948
Oil paint on canvas
130 × 97
Istanbul Museum of Modern Art Collection
Eczacıbaşı Group Donation

23
Untitled 1950
Mixed media on paper
77.5 × 58
Sevtap and Tolga Kabataş Collection

24
Untitled
(Brighton 9 June 1949) 1950
Mixed media on paper
80 × 60
Sevtap and Tolga Kabataş Collection

25
The Octopus of Triton 1953
La Pieuvre de Triton
Oil paint on canvas
181 × 270
Istanbul Museum of Modern Art Collection
Eczacıbaşı Group Donation

26
Basel Carnival 1953
Carnaval de Bâle
Oil paint on canvas
200 × 280
Sammlung Ludwig, Ludwig Forum
für Internationale Kunst, Aachen

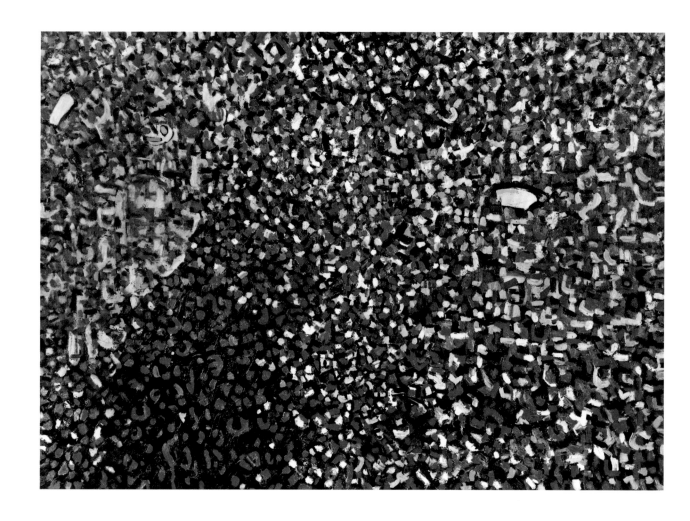

27
Sargasso Sea 1953
La Mer des Sargasses
Oil paint on canvas
197 × 278.5
Istanbul Museum of Modern Art Collection
Eczacıbaşı Group Donation

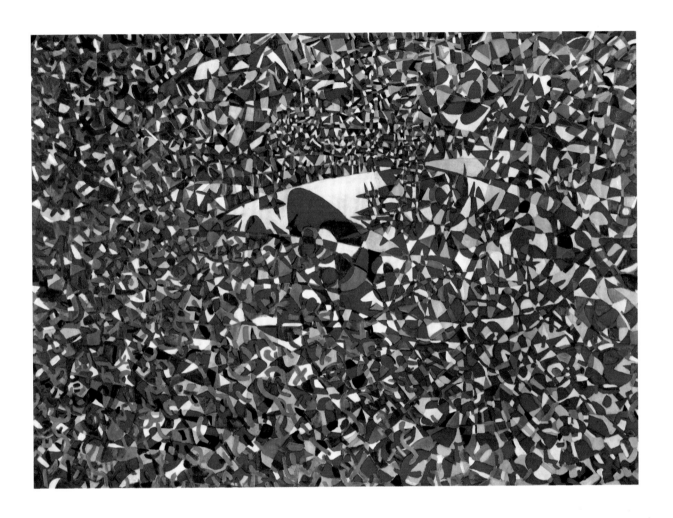

28
The Arena of the Sun 1954
L'Arène du Soleil
Oil paint on canvas
196 × 269.5
Istanbul Museum of Modern Art Collection
Eczacıbaşı Group Donation

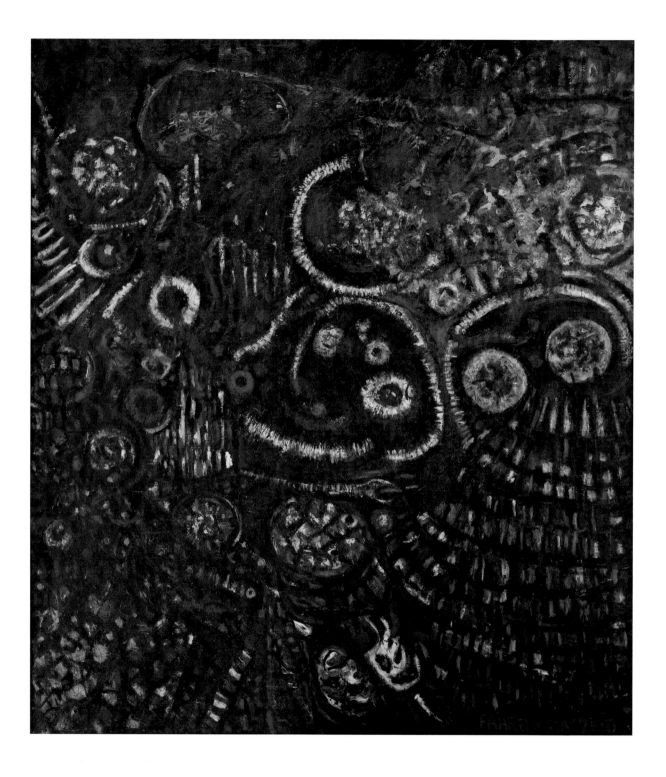

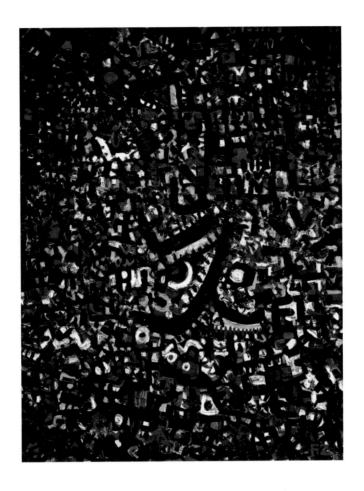

29
Alice in Wonderland 1952
Alice au Pays de Merveilles
Oil paint on canvas
236 × 210
The Raad Zeid Al-Hussein Collection

30
Ubu Bird ('The Phoenix') 1952
L'Oiseau Ibu-Phoenix
Oil paint on canvas
146 × 113
Sevtap and Tolga Kabataş Collection

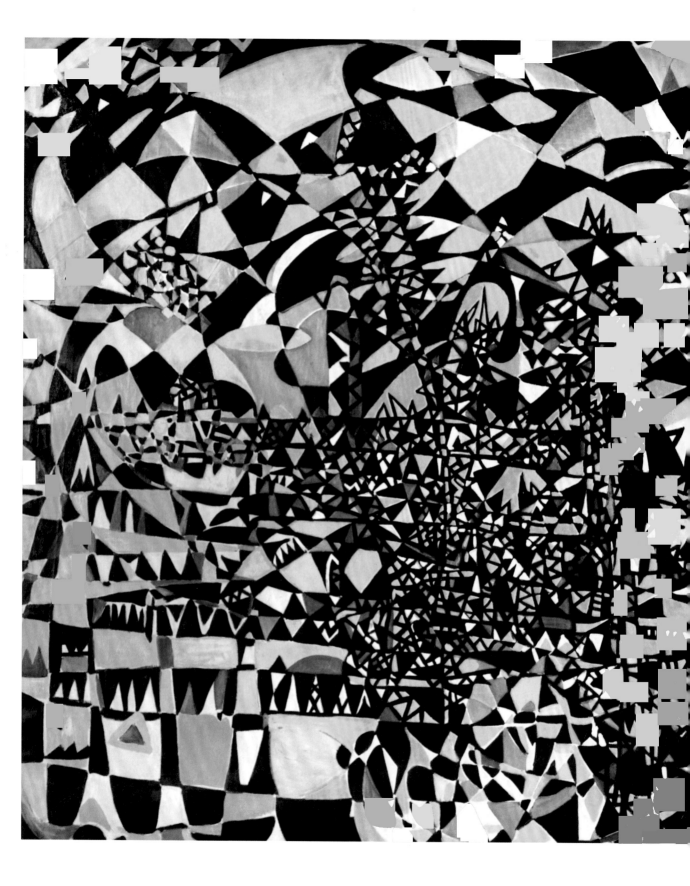

31
My Hell 1951
Oil paint on canvas
205 × 528
Istanbul Museum of Modern Art Collection
Shirin Devrim Trainer and Raad Zeid Al-Hussein Donation

33
Untitled c.1950s
Oil paint on canvas
182 × 222
Tate. Presented by Raad Zeid
Al-Hussein 2015

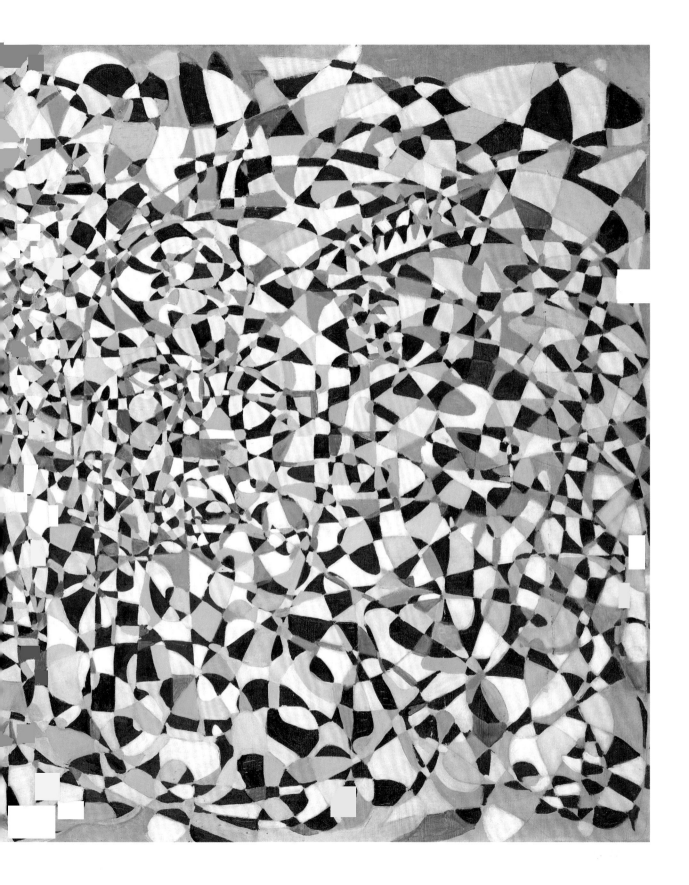

34
Intermittence...Sand...
Water...Sun 1953
Intermittence...Eau...Soleil
Oil paint on canvas
185 × 452
Istanbul Museum of Modern Art Collection
Eczacıbaşı Group Donation

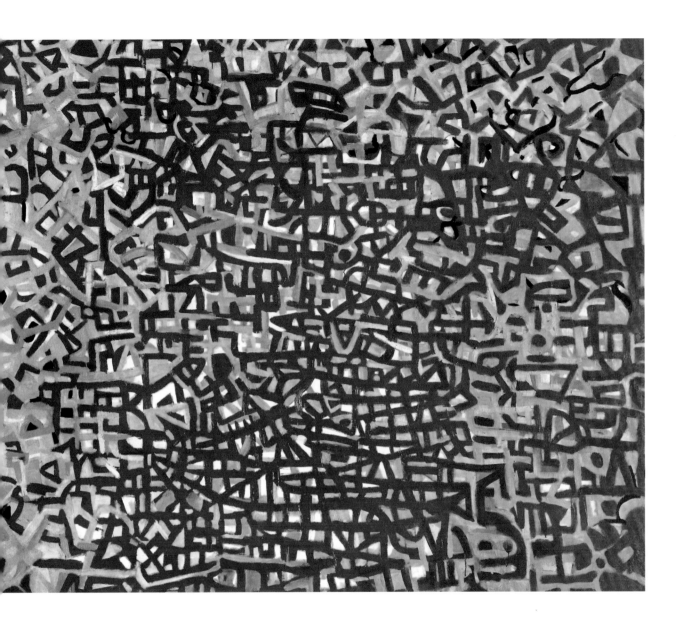

35
Untitled n.d.
Mixed media on paper
46 × 36.5
The Raad Zeid
Al-Hussein Collection

36
Untitled n.d.
Ink on paper
37 × 30.5
The Raad Zeid
Al-Hussein Collection

37
Untitled n.d.
Ink on paper
64 × 53.5
The Raad Zeid
Al-Hussein Collection

38
Untitled n.d.
Ink on paper
39 × 49
The Raad Zeid
Al-Hussein Collection

39
Untitled c.1953
Mixed media on paper
44 × 58
The Raad Zeid
Al-Hussein Collection

40
Untitled c.1950s
Lithograph on paper
64 × 56
The Raad Zeid
Al-Hussein Collection

41
Untitled 1954
Lithograph on paper
63.5 × 52
The Raad Zeid
Al-Hussein Collection

42
Untitled c.1950s
Lithograph on paper
76.5 × 56
The Raad Zeid
Al-Hussein Collection

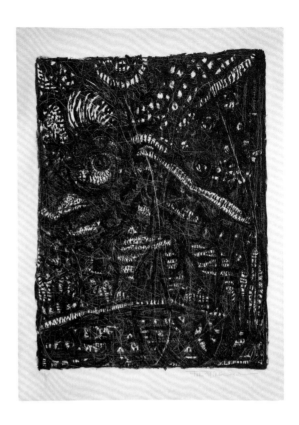

43
Untitled c.1950s
Lithograph on paper
65 × 50
The Raad Zeid
Al-Hussein Collection

44
Untitled c.1950s
Lithograph on paper
76.2 × 56.5
The Raad Zeid
Al-Hussein Collection

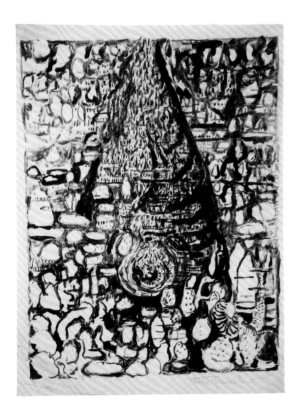

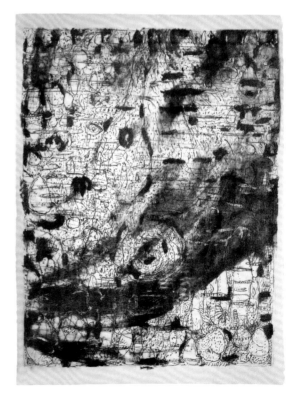

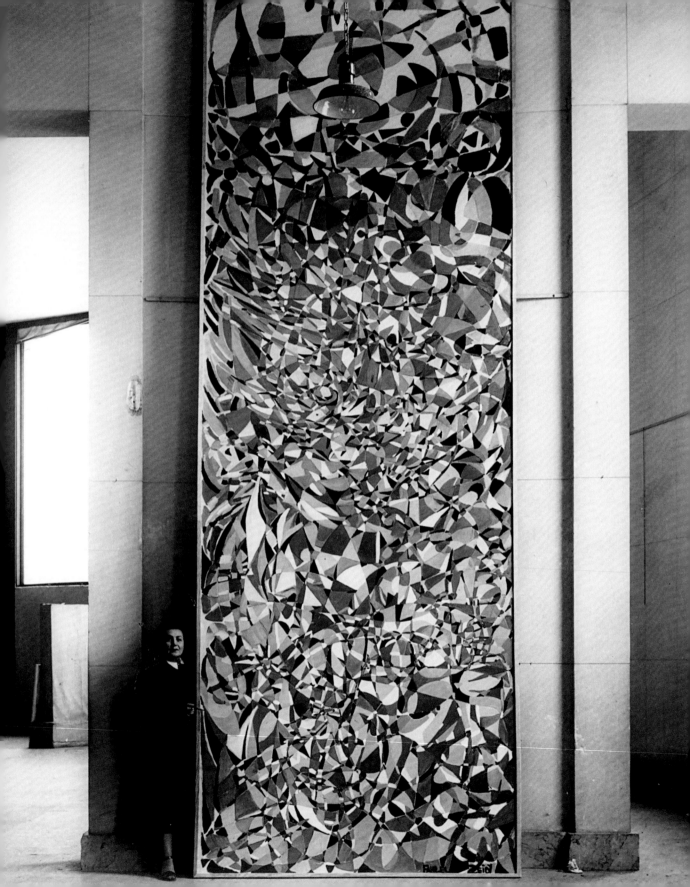

Extravagant Reinventions: Fahrelnissa Zeid in Paris

SARAH WILSON

Fahrelnissa Zeid is surely the most flamboyant female representative of the Nouvelle École de Paris. Her large paintings remain unrivalled in their ambitious scale by any woman artist until Joan Mitchell and her 1960s triptychs, made in Giverny.[2] Paris, the 'incomparable city' for Zeid, was the uncontested capital of the arts until 1939, and retained its pre-eminence after 1945, with new intellectual and artistic groupings.[3] It had welcomed Turkish artists since the early nineteenth century.[4] Zeid was brilliant, dominating, well connected and fluently francophone; her sudden appearance in the 1940s, her success, her excess, her social position and her stylistic variations and eccentricities, assaulted the male bastions of Parisian art criticism, while revealing far older historical debates.[5] She should long ago have joined France's artistic pantheon.

Zeid was exposed to French culture as a very young girl. Before the outbreak of the First World War, her formative years were spent at Notre-Dame de Sion, a French convent school in Istanbul, a period that provided a reprieve from a complicated family life. In Turkey in the 1920s and 1930s she witnessed, at close quarters, Mustafa Kemal's project of modernisation, which was based on a French revolutionary and republican model. At that time, French influence was everywhere in Istanbul, from the work of architects such as Albert Laprade to that of Parisian painter Léopold Lévy, who became director of the İstanbul Güzel Sanatlar Akademısı (Istanbul Academy of Fine Arts), and reorganised the teaching of painting. When Zeid had an opportunity to study abroad in 1928 she chose the Académie Ranson in Paris, where she was taught briefly by Roger Bissière (who wanted to 'break' her will, for her own sake and later became a father figure for the primitivist abstraction of many in the 'new' School of Paris).[6] For most of Zeid's life she thought and wrote in French and, in 1938, when struggling with depression in Baghdad, it was to Paris she desired to return. Although Zeid travelled extensively and lived in

FIG.22
Zeid during the installation of
Towards a Sky 1953, Musée des
Beaux-Arts de la Ville de Paris, 1953

89

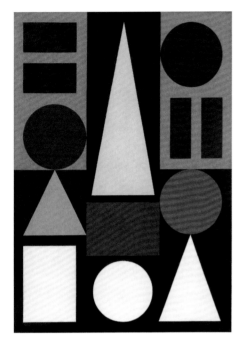

many places, the city in which she felt most at home was Paris: its allure remained strong throughout her life.

When Zeid arrived in London in 1946, she encountered a strongly Francophile intelligentsia.[7] Following the opening of her first exhibition in London at Saint George's Gallery in February 1948, the *Spectator* perceived that 'Her contact with Paris has resulted in an unusual fusion of oriental vision with certain Western forms of expression.'[8] *Street in Baghdad* on the catalogue cover and similarly undated paintings such as *Fishing on the Bosphorus* recalled her past, as did many watercolours; while landscapes from Scotland evidenced Zeid's embrace of her new life. For her subsequent exhibition in 1949, Zeid chose the most Parisian of London galleries, Gimpel Fils.[9] The semi-abstract, bird's-eye view of *Loch Lomond* 1948 (no.15) was stylistically hybrid; meanwhile, views of Hyde Park, The Regent's Park, Paignton and Torquay and *High Seas at Eastbourne* 1948 revealed Zeid's wider discovery of Britain.

The European abstraction to which she would turn was still a contested field, however. After her first encounter with Paris, but before arriving in London, Zeid had experienced Adolf Hitler's Germany, and apparently Hitler himself, in her role as ambassador's wife (1935–8). She had witnessed the '1930s turn' and the emergence of proto-fascist aesthetics and styles (also transmitted to Turkey).[10] While visiting many museums and enjoying Germany's cultural richness, Zeid could not have ignored the threat to abstract painting posed by Hitler's campaign against 'degenerate art', nor the life-threatening consequences for artists of Jewish descent. The cosmopolitanism of Paris had also been challenged by growing anti-Semitism, and with the German invasion of 1940, the capital would be tainted by persecution and deportation. Hence the affirmative joy in making abstract art in Paris after the war, and in transmitting it to new generations – a joy which Zeid would share.[11]

Despite her privileged status in London as wife of the ambassador of Iraq to the Court of Saint James's and the gorgeous parties and salons she held, surrounded by her paintings at the embassy, Zeid functioned in an austerity-driven city governed by the rules of a stiff, class-based society.[12] England looked with longing towards the

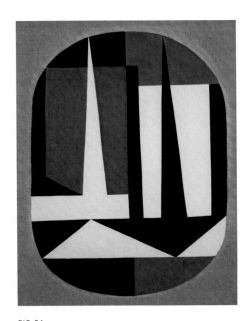

brighter Continent, delighting in the Matisse and Picasso exhibition at the National Gallery in 1945, and the Vincent van Gogh exhibition in 1947. Zeid's son, Nejad's show at Saint George's Gallery in 1949 was entirely Parisian in style and prefaced by French art critic Jacques Lassaigne.[13] It preceded the Royal Academy's gentle *School of Paris* retrospective in 1950, with its 'old masters' such as Georges Braque.[14] Paris beckoned, intact, with the chic of Saint-Germain-des-Prés, new jazz groups and scintillating night life. Here, Jean-Paul Sartre's existential philosophy became the byword for self-reinvention, with new styles and new female heroines such as Juliette Greco or Françoise Sagan entering the popular consciousness, not to mention Sartre's partner, the feminist Simone de Beauvoir.[15] Zeid opted for the best of both worlds, becoming a passionate, if intermittent Parisian (her work and Nejad's had featured in the contemporary Turkish artists' exhibition at the Musée Cernuschi as early as 1946).[16] While Nejad had a Montparnasse studio in the rue de la Grande Chaumière, Fahrelnissa chose the rue Jean-Bart.

The canon – including the European canon – has ignored great female abstract artists working in Paris at this time, such as Aurélie Nemours, Carmen Herrera or Zeid, now internationally recognised.[17] Her social connections notwithstanding, Zeid's art-world allegiances were crucial: her Parisian career may be closely linked to three remarkable women: Colette Allendy, Dina Vierny and Katia Granoff, the gallerists who gave her shows throughout the so-called *trente glorieuses* – the three decades of Parisian glory. Allendy, herself a painter, had lived, with her husband René, through the pioneering adventure of psychoanalysis in the 1930s; Vierny, the beautiful Russian-Jewish model – sculptor Aristide Maillol's perfect 'Mediterranean' body – ran one of the most powerful galleries in the 1950s; Granoff, born in Ukraine, a poet and translator, and a Parisian gallerist from 1926, was Zeid's active *complice* during both women's seventies.[18] In a largely male-dominated post-war environment, these gallerists, along with Suzanne de Coninck – director of the Galerie de Beaune, which showed and published Zeid's work – and Lydia Conti, Denise René or Iris Clert, were the movers and shakers of an avant-garde that contested the powerful structures of the art-world establishment.[19]

'Princess' Zeid's first Parisian solo show took place (two years later than Nejad's) in December 1949, at the Galerie Colette Allendy in the smart sixteenth arrondissement. The catalogue was prefaced by no less than André Maurois, of the Académie française. He situated her art between 'the most primitive of Byzantines' and Georges Rouault. Denys Chevalier, also writing, was intrigued by the contrast between her 'miniaturist' spirit and the already monumental ambition evidenced in large-scale works demonstrating a limitless fragmentation of planes.[20] The gallery had already held Francis Picabia's first post-war retrospective (1947) and the key avant-garde exhibition *HWPSMTB* of April 1948, in which Picabia linked up with the new abstract and *informel* tendencies of Hans Hartung, Wols, François Stahly, Georges Mathieu, Michel Tapié and Camille Bryen. Fahrelnissa Zeid's name, calligraphed in scarlet Arabic script on the catalogue cover, proclaimed her origins: it was a statement of exotic presence (reversing Atatürk's official insistence on the Latin alphabet).[21] Despite the new vogue for quasi-orientalist sign-making among painters such as Hartung, or the future evolution of Mathieu from a Zen-inspired austerity to calligraphic performances in the late 1950s, Zeid's work itself did not pursue this Japan-oriented East-West dialogue.

Instead, she chose the arena of geometric abstraction – international and particularly dynamic. With its long pre-war heritage, it looked forward to the sharper era of the late 1950s, to 'op' and kinetic art, and the advent of pop in design.[22] The heroic pioneers of pre-war dada and abstraction were highly visible in Paris; there was no caesura followed by a 'neo-avant-garde'. Hans Arp prefaced a 1948 show of abstract tapestries, including those by his late wife Sophie Tauber, at Colette Allendy's gallery; Arp, Sonia Delaunay and Nelly van Doesburg were on the first post-war committee of the Salon des Réalités Nouvelles in 1946, where Picabia and František Kupka resumed their abstract conversation of 1912.

The new Salon des Réalités Nouvelles exploded, growing from 84 artists in 1946, to 212 in 1951. At this latter exhibition, Zeid triumphed with her huge painting, *My Hell* 1951 (no.31). Two metres tall and over five metres long, it was hung impressively high on the bare stone walls of the Musée des Beaux-Arts de la Ville de Paris. By this time,

Alexander Iolas had also given Zeid a show at the Hugo Gallery in New York.[23] In a letter of commiseration for a less than stunning success, Iolas tells her about the Betty Parsons Gallery's 'new American school, very nationalist and antiforeigner' … that will 'save world painting and deliver condemnations, like the Last Judgement. You've perhaps seen Jackson Pollock, and you know what I mean by this?'[24] Zeid's impressive expansion of canvas size surely found corroboration in Pollock's work, which she may have seen first hand; later only works of medium dimensions were shipped to Paris for his first solo appearance there at the Studio Facchetti in 1952.[25]

Despite her evident success, positioning Zeid had seemed a problem from the outset. 'What tendency, what group does Fahrelnissa Zeid belong to? What school do her works spring from?' Denys Chevalier had asked in 1949.[26] Paradoxically, during this period of triumph, where the format and dimensions of her crisp and swirling coloured abstractions eclipsed those of work by her male counterparts, her most famous future ally, critic Charles Estienne, asked the previously unthinkable: 'Is abstract art an academicism?' A Kandinsky enthusiast, he disliked cold, 'geometric' abstraction. He would, by 1954, become the promoter of what he called the *tachiste* revolution, and was no doubt a force in Zeid's mutation towards so-called 'lyrical abstraction', in dialogue with late surrealism.[27]

Midi Nocturne (Nocturne at Noon) demonstrates the ripening collaboration of Zeid and Estienne. In the tradition of the French *beau-livre* (an artist and writer's collaboration) this modest publication of 1951 celebrated her exhibition, *Fahr-El-Nissa Zeid: Peinture – Gouaches – Lithos,* at the Galerie de Beaune. It revels in the oxymoron of its title, brimming with antitheses and complementarities based on East–West comparisons, beginning with Zeid's 'black noon' experiments – inky nights pierced with white suns and stars, scratched with cosmic trajectories – which showed her mastery of the lithographic technique (fig.25).[28] Estienne's text is an exercise in writing – *écriture* – not criticism: a meditation about Zeid's place within interpenetrating artistic and literary traditions. He writes after medievalist Émile Mâle and other scholars' thoughts on stylistic transmission from East to West along the Silk Roads, and after Fernand Braudel's promotion of the *longue durée* – the longer time-scale within which

historical evolutions may be contemplated – with its focus on the Mediterranean basin that gave birth to Zeid.[29] Above all, Estienne writes in the wake of writer André Malraux's thoughts on a global 'imaginary museum'. A Gaullist politician at the time, Malraux's Asian travels and trophies of the 1930s fed directly into his three-volume post-war *La Psychologie d'art* (The Psychology of Art).[30] In Malraux's *Les Voix du silence* (Voices of Silence) anthology, contemporary with *Midi Nocturne*, time is abolished thanks to photography, in a spread where the famous thirteenth-century angel of Reims cathedral exchanges smiles with a fourth-century Gandara Buddist head from Afghanistan. Extraordinary parallels of emotion and expression collapse complex art-historical debates, where stylistic transmissions traverse centuries and religions.

Estienne's text mirrors these emotions, these debates. Zeid loved his preface so much that she copied and illuminated the manuscript that he offered her in the *livre d'or* of her exhibition.[31]

And light came from the Orient. And here, once more, Night awakens; not the black void, the cold and abstract death of all things, their inexistence like their eradication on the cold and abstract page of a book invaded by printer's ink thirsting only for ideas, but this live and breathing Night which is not the absence of day but its other side, its heat and place of origin, present at high noon, the great twilit Night of Novalis and Nerval, the bright and funereal kingdom where, immobile, exchanging only their sceptres, the Mother Godesses of the Orient and Black Virgins of the West keep watch – the strange nocturnal Noon which fabulously reunites in the same tumultuous embrace the burning bush of Aix and the stained-glass of Chartres, Séraphine de Senlis's tree and Fahrelnissa Zeid's nomadic palaces.[32]

With an incantatory sweep over time and space, Estienne's essential comparison between Zeid's flamboyance (merging implicitly with 'flamboyant gothic' style) and the work of the naive painter Séraphine de Senlis is not unproblematic. Séraphine, based in the beautiful cathedral town of Senlis outside Paris, was discovered fortuitously by cubist expert Wilhelm Uhde in the 1920s: she was his domestic servant.[33] Her swirling plant forms with their teardrop

shapes may, indeed, be compared with the unusual tracery of Senlis's gothic rose window, but the categorisation of Séraphine was always as a female 'primitive'. Zeid, too, Estienne implies, shares a femininity linked to the decorative, to excess, and to the naive, which separates her abstraction from, say, that of the 'theorised' geometric production of August Herbin or Victor Vasarely, her contemporaries.

Zeid became, at this point, a member of what Estienne termed the 'Nouvelle École de Paris', together with Nejad.[34] With greater post-war mobility, Paris as an art centre was becoming ever more international – the destination of choice for American G.I. Bill art students, for privileged Eastern Europeans or for anti-fascist artists from Spain, for example.[35] *Fahr-El-Nissa Zeid*, at Dina Vierny's gallery in the rue Jacob, marked a high point: this was the show that would travel almost unchanged to London's most avant-garde space, the Institute of Contemporary Arts, with the addition of *My Hell* 1951, in 1954.

FIG.26
Rose window,
Senlis cathedral

FIG.27
Séraphine de Senlis
The Tree of Life
L'Arbre de vie 1928
Enamel and oil paint
on canvas
145 × 114
Musée d'Art et d'Archéologie
de Senlis, France

FIG.28
Aurélie Nemours
Archaic c.1950
Archaïque
Oil paint on canvas
55 × 46
Courtesy Galerie Antoine
Laurentin, Paris

Zeid's large-format, geometric painting now surely astounded her previous English admirers.[36] Her catalogue was graced with a poetic preface by Roland Penrose: painter, surrealist and Picasso scholar.[37] London now witnessed her phoenix-like resurrection, (ratified once more in 1957, when the French emigré Philippe Granville chose her to inaugurate his new private house-gallery near Lord's cricket ground).[38] *Towards a Sky* 1953 (see frontispiece) would dramatically dominate a group show there, measuring approximately six metres tall and supported vertically on a structure in his garden – an amazing sight just before sunset.[39] Her painted stones, such as *The Man of the Mallorca Sands* also attracted attention at this time.[40]

Like many of her contemporaries, Zeid gave semi-abstract works titles that encouraged figurative readings; *Le Feu d'Artifice* (later titled *London* ('The Firework') before 1972; no.70), for example, may be positioned in the lineage of Thames views by artists such as Claude Monet and André Derain. To Vierny and others, Zeid's paintings recalled the geometric rug patterns and jewels depicted in her works of the early 1940s (indebted to Matisse's orientalism), just as Serge Poliakoff's abstractions evoked the colours and composition of Russian icons.[41] Zeid could also invent abstract works related to a theme: for Estienne's whimsical *Alice in Wonderland* show of 1955, for example, or his *L'Ile de l'homme errant* (The Isle of the Wandering Man) of 1956 (both held at the Galerie Kléber, Paris). In these shows she was joined by female artists Marcelle Loubchansky and the Czech surrealist Toyen (Marie Čermínová), together with surprising figures such as the veteran Marc Chagall.

Self-reinvention was not only for painters at this time: surrealist leader André Breton blurred the boundaries between surrealism and lyrical abstraction in 1955 when he wrote on the gestural works of Jean Degottex – continuing all the while to thrill female artists with his patronage.[42] He wrote to Zeid:

> In the most secret realms of my heart I keep forever the echo of works which have come to me from you, like a ray emanating from those admirable geodes which are born and stretch out at will beneath your fingers; and which by force will pierce all shadows.[43]

The metamorphosing surrealist spirit embodied by the remit of journals such as Breton's *Le Surréalisme, même* or Edouard Jaguer's review *Phases* now embraced Zeid.[44]

Breton's 'geodesic' metaphor for the transparent crystalline structures in Zeid's paintings and painted stones anticipates her turn, in the later 1960s, to the *paléokrystalos* sculptures. The Comte de Lautréamont's famous dictum: 'poetry should be made by all' – emphasising the democracy of the subconscious – together with the long heritage of surrealist objects and a new emphasis on *bricolage*, provides their matrix.[45] Could one also, however, see them as miniature and portable memorials? On Bastille Day, 14 July 1958, the pan-Arab uprising in Iraq would annihilate the remaining Hashemite dynasty, installing a new, militarised regime, allied with Communist countries. Did the *paléokrystalos* also represent a symbolic and therapeutic practice, creating a space and time for contemplation of the slaughtered family whom Zeid now mourned from afar? (At a time of intense Cold War debate, 'the Princess' and her art never engaged with the left or with anti-colonialist stirrings: the nostalgic orientalist framing of her work would contrast strongly with that of Nejad, who travelled in Eastern Europe and Soviet Asia and later settled in Poland).

Fortunately, Zeid and her husband were summering in Ischia at the time and were spared the massacre. They were however expelled from the London embassy and given a mere twenty-four hours to vacate the premises. Reduced to the status of ordinary citizens, the couple moved to a private apartment in London. A note written in French shows Zeid's resolution in the face of tragedy and adversity, a positive decision to construct – to reconstruct – her happiness: '*J'ai decidé de construire – mon bonheur*'.[46] Back in Paris again, she transformed a turkey and a chicken carcass, painting the bones, which she showed to Malraux – who declared them 'art' – prior to discovering she could embed them in resin, which generated the translucent *paléokrystalos*, revolving on motorised turntables.[47]

A new aggression – close to the chaotic, spiky work of the CoBrA artists (from Copenhagen, Brussels and Amsterdam) – entered Zeid's work, resonating with the troubled period of the Algerian war. The spiky, hybrid image on the poster for her 1961 exhibition with Dina

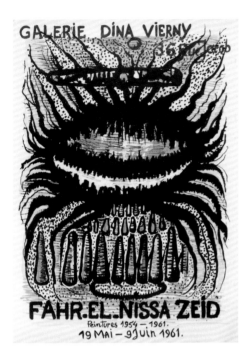

Vierny suggests an arachnid predator or a black sexual orifice – and anticipates the dark eyelash fringes on her later portraits (fig.29). Yet Zeid was also softening her style at times, blurring and shading edges, implying a change that effects a *rapprochement* with lyrical abstraction – indeed with the contemporary work of her teacher Bissière (still highly influential) or the stained-glass hues of French painter Alfred Manessier.[48] Estienne described her painting as an 'infinite unrolling', like a *peinture de caravane* – a nomadic metaphor for her 'immense canvas of abstract writing' – and, again in her large, cursive script, she transcribed his homage:

> Let us decipher, follow the meanders of this writing which continually turns back on itself without ever ending, like the song of the muezzin or a flamenco canto. It's true, we're in the midst of the Mediterranean between Orient and Africa (and the Paris sky).[49]

Her interior suffering persisted. A friend wrote from Australia:

> For a few years we were gravely concerned that you yourselves had met graver disasters … I find it hard to realise that your dynastic life, so to speak comes to an end.[50]

Yet this was the optimistic period between Yuri Gagarin's circling of the globe and the American conquest of the moon – hence *Break of the Atom and Vegetal Life* 1962 (no.59) and *L'intrus, la Lune et le Cosmos* 1968 (the magnificent canvas in contrapuntal black and white later renamed *The Fight of the Moon and the Astronaut* no.68), both over five metres long.

In 1969, Katia Granoff, the most senior female gallerist in Paris, showed Zeid's works, including the 1966 series 'Reminiscences', with the *paléokrystalos*. Breton's appreciation of the *géodes* was reproduced in the catalogue. The paintings were shown with designer frames by Claude de Muzac, who, at the same time, was using cork to surround painter and sculptor Yolande Fièvre's reliquaries of driftwood, bone, and pierced pebbles. Fièvre offers an interesting parallel: despite training at the École des Beaux-Arts, Paris, and teaching at the Beaux-Arts in Orléans, she adopted a deliberate 'autodidact' position and cultivated friendships with Breton and Jean Dubuffet. For both

women, the 'School of Paris' (or 'Schools of Paris') critics, cliques and gallery allegiances could be a straightjacket: the attempt to achieve a more personal form was a release, and entailed an embrace of new discourses around 'naive' or untutored art. Here Dubuffet's idea of an *art brut*, an art produced outside cultural norms and constraints, encountered critic Michel Tapié's broader remit – an *art autre* (other art) which could include Dubuffet's own graffiti and matter-based experiments, or those of his Philippino supporter, Alfonso Ossorio, who also exhibited with Zeid.[51] The movement was in both directions: from abstraction closer to surrealism; or from surrealism to lyrical abstraction for Hungarian painter Judit Riegl, or the emigré Czech artist Iaroslav Serpan, who abandoned surrealism for a cosmic, enlarged *informel* surface contoured with nylon tights and other household *débris*. *Art autre* would become an internationalist enterprise, reaching across Europe to Asia and with new nodal points in Barcelona or Turin: Nejad was part of this adventure.[52]

Liberty was the watchword: the liberty that Zeid, encumbered by too wealthy, too complex a past, now permitted herself to embrace. She wrote: 'Life played me its serenade and I danced around it like a gypsy.' Looking back on the years and their constraints, the suffering, their hold on her: 'thirsty, mad, blind, pursued, lamenting, I ran to the brazier, which engulfed me, that's why I'm now joyful.'[53]

By the time she exhibited her portrait series with Katia Granoff (now a venerable seventy-seven years old) in 1972, Zeid herself was seventy-one; her rather tragic, heavily made-up film-star gaze greets us in the staged catalogue frontispiece. Granoff provides an exotic genealogy for both Zeid and her portraits:

> She adores grandeur and the absolute like the king, descendant of Alexander, who erected a pantheon, half-Greek, half-Persian at Nemrut-Dag two thousand years ago; where at the foot of giant statues, colossal heads are raised.[54]

Her portraits, with their enlarged heads and protruding permanently open eyes – 'discs of lost time' – may indeed be compared to the giant fallen heads of sculptures from Antiochus's Hellenistic temple tomb (*hierothesion*) with its hybrid stylistic ancestry. Granoff's emotional tribute to Zeid, in a strange film shot by Vierny's

son, Olivier Lorquin, in 1975, repeats the analogy. Here we see the huge scale of the portraits as Zeid works closely on their surfaces, insisting nonetheless on the necessary distance of her models as she recreates their psychic doubles: the mesmeric, Coptic stare of her late husband Prince Zeid Al-Hussein (no.74); the wistful, mystic gaze of Charles Estienne (no.72); the gallerist Iris Clert (no.73), eyes hermetically closed, nonetheless self-confident in her pale jacket with asymmetrical collar and mink button over half-exposed breast — or the short-lived vulnerability of the *Adolescent* c.1965–6 (Olivier Lorquin, himself) who recalled for me his sittings and Zeid's insistence that he wear his white velvet waistcoat.[55] Prior to the move to Amman, Jordan, in 1975 (see Laïdi-Hanieh, pp.131–140), the portraits offered a picture gallery of her life, the conspicuously missing element being Zeid's artist son Nejad, who was pursuing his own Parisian, then Eastern, adventures.[56]

In 1990, one year before the artist's death, Paris again saw a spectrum of Zeid's work. At the Institut du monde arabe, Jean

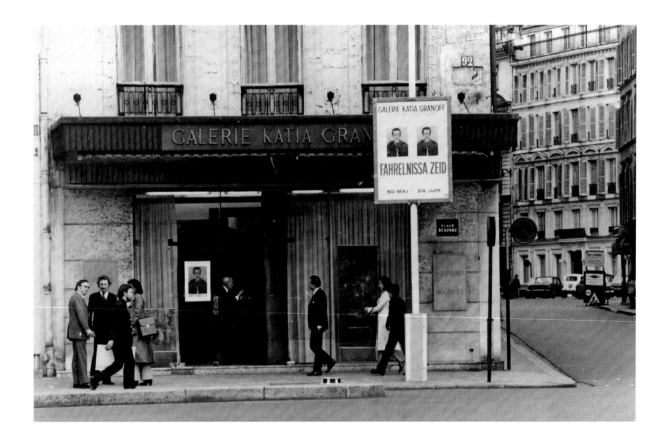

Nouvel's 'perforated' metal filigree facade, responding to sunlight, sheltered her painting, just as the *clair-obscur* veils had controlled the vision of the artist in her teenage years. *Trois femme peintures: Baya, Chaïbia, Fahrelnissa* definitively positioned Zeid's work with that of the naive, the untutored 'Arab' sisters of Séraphine de Senlis: Chaïbia Talal, the Moroccan peasant – a widow and mother at 15 – and Baya Mahieddine, the orphaned Algerian prodigy and domestic servant.[57] Within this triad, Zeid, the sophisticated diplomat's wife is 'disappeared', along with the forceful geometric abstract artist, the Paris years and triumphs, the enterprises of her determined female gallerists, the poetry of her critics.[58] Institutional ideologies may be as constraining today as the concept of a 'School of Paris', the mantras of 'late' or of 'multiple' modernisms, or the asymmetric 'West to East' construction of 'Orientalism', ignoring opposite movements and more complex narratives, memories and inventions.[59]

Paris remains cosmopolitan, welcoming artists of every nationality. In 2010 the Musée du Montparnasse celebrated 'Nine painters of the Turkish School of Paris' (without Zeid) — re-establishing the vital context of her compatriots during the Paris years, including Nejad and his circle.[60] Mainstream museums and galleries now acknowledge many more artists with Paris affiliations, though all too often the dialectic between birthplace and the 'global' obliterates Paris's own gift of internationalism.[61] Far more than lessons in paint, Paris as a 'school' was about exchange and passionate discussion; it was an education in life, in style and an intellectual *modus vivendi*. The different abstract tendencies linked to Estienne or other critics were always a question of fashion, emulation, personalities, and were subject to slippage, a *glissage,* into figuration, into discourses around child art, *art brut,* the 'naive'. Zeid's openness to experimentation, changes of style and large-scale self-reinvention through the decades, indeed the disconcerting aspects of some late figurative works, give her art its dimensions of vulnerability and risk, all contributing to her contemporary appeal.

1 'C'est une messagère, une messagère attendue, désirée, un astre, une comète qui a passsé par Paris… Fahrelnissa Zeid, vous ne partirai jamais de Paris… vous nous appartenez, et vous apportez notre message à notre tour dans ces pays orientaux' Katia Granoff, filmed by Olivier Lorquin, 1975 (all translations author's own).

2 Joan Mitchell lived between Paris and Giverny, neighbouring the impressionist Claude Monet's home, from 1959 to 1992. *See Girolata Triptych* 1963, oil paint on canvas, 194.9 × 301.6 cm, private collection.

3 André Bloc, letter to Zeid quoting her words on Paris, 'cette ville incomparable', 20 August 1951, Zeid archives.

4 Mekteb-i Sultani (The School of the Sultan) was founded in Paris for Turkish painters who were sent to France in the 1860s during the Tanzimat (Reformist) period. Turkish artists first studied in the atelier of the painter Jean-Léon Gérôme at the École des Beaux-Arts.

5 See Marc Duvillier (ed.), *L'Aventure de l'art abstrait: Charles Estienne, critique d'art des années 50*, Brest 2011.

6 Participating in this 'primitivist turn', Zeid procured books on the Stone Age, primitive sculpture, Celtic art and the art of ancient Crete, from Quaritch's bookshop, London (undated typscript, Zeid archives). Zeid's encounter with Bissière is related by André Parinaud in Parinaud (ed.), *Fahrelnissa Zeid*, Royal National Jordanian Institute Fahrelnissa Zeid of Fine Arts, Amman 1984, p.37.

7 See 'Londres, 15 Kensington Palace Gardens, November 1949', Zeid's notebook, Zeid archives. Close wartime ties between the two nations remained strong; Cyril Connolly's journal *Horizon: A Review of Literature and Art* translated the latest French artists and writers.

8 M.H. Middelton, 'Art', *Spectator*, 20 February 1948, p.14.

9 Fahrelnissa Zeid, letter to Mr Collis, preferring the new Gimpel spaces to the Hanover Gallery, run by Erica Brausen, with an invitation to the Art Council of Great Britain's *Contemporary Turkish Painting*, 23 October 1948, Zeid archives.

10 At the State Academy, Rudolf Belling, in flight from Nazi Germany and a brief New York sojourn, reorganised sculpture; Bruno Taut relocated from Japan in 1936 to work there in architecture and urban planning. See Katharina Wilhelm, 'An unbroken link: Rudolph Belling's ties to his homeland and abstract experiments during exile in Turkey in the context of German post-war politics and remigration', unpublished MA thesis, The Courtauld Institute of Art, University of London 2009.

11 See *Art Concret*, Galerie René Drouin, 15 June–13 July 1945 – the post-war relaunch of abstraction.

12 For parties and Zeid's salon, see Maurice Collis, *The Journey Up: Reminiscences, 1934–68*, London 1970, pp.101–6. A biography and lists of works on Iraqi embassy paper in the Zeid archives suggest a handlist for guests. Compare the still-grim photographs in Sergio Larrain's *London 1958–59*, Stockport 1998.

13 *Néjad: Paintings*, Saint George's Gallery, London, from 9 February 1949; recent participation in the Salon de Mai and Salon des Réalités Nouvelles and the Galerie Maeght's *Les Mains Éblouies* are mentioned. Néjad's abstractions are close to those of André Lanskoy in style.

14 The 'School of Paris' as euphemism for Jewish artists did not reach England: see Oliver Barker, 'Art from France in Britain, c.1948–1959. Influence and Reception', unpublished MA thesis, The Courtauld Institute of Art, University of London 1993.

15 For a more complex discussion, see Sarah Wilson 'The Search for the Absolute', in Frances Morris (ed.), *Paris Post War: Art and Existentialism 1945–55*, exh. cat., Tate Gallery, London 1993, pp.25–52.

16 René Grousset, *Peintures turques d'aujourd'hui: Turquie d'autrefois*, exh. cat., Musée Cernuschi, Paris 1946 (not to be confused with the UNESCO International exhibition of 1946 at the Musée Nationale d'Art Moderne, where Zeid also showed.)

17 See *Aurélie Nemours: Rhythme, nombre, couleur*, exh. cat., Musée National d'Art Modern, Centre Pompidou, Paris 2004; Dana Miller, *Carmen Herrera: Lines of Sight*, Whitney Museum of American Art, New York 2016; and Zeid's participation in the Istanbul Biennial in 2015.

18 See Katia Granoff, *Anthology de la poésie russe*, Paris 1961; also, Katia Granoff, *Ma vie et mes rencontres*, Paris 1992.

19 See also Christian Derouet (ed.), *Jeanne Bucher: Une galerie d'avant-garde, 1925–1946*, exh. cat., Musées de la Ville de Strasbourg, 1994; Iris Clert, *Iris-time, l'aventure*, Paris 2003 (1975); and *Denise René, l'intrépide*, exh. cat., Centre Pompidou, Paris 2001.

20 André Maurois, 'Le plus primitif des Byzantins' and Denys Chevalier, 'La fragmentation indéfinie des plans', in *Fahr-El-Nissa Zeid*, exh. cat., Galerie Colette Allendy, Paris 1949, reprised in Parinaud (ed.) 1984, p.150.

21 See Francesca Caruana, 'Calligraphie, peinture, un regard sur le signe Islamique', in *Le Monde Islamique et l'image. Hommage au poète espagnol José Angel Valente*, special number of the series 'Horizons maghrebins 44', 2001, pp.38–52.

22 See Dominique Viéville, 'Vous avez-dit géometrique?', in Germain Viatte (ed.), *Paris-Paris: Créations en France, 1937-1957*, exh. cat., Centre Pompidou, Paris 1981, pp.270–82; and http://www.folmer.net/wp-content/uploads/ 2012/ 01/salondesrealitesnouvelles.pdf, accessed 14 December 2016.

23 *The Oriental Painter, Fahr-El-Nissa Zeid*, Hugo Gallery, New York, 9–29 January 1950 (catalogue text based on the Gimpel Fils preface, 1949).

24 Ici, depuis une année il y a une ecole americaine, tres nationaliste et tres antietranger… le groupe importante qui sauvera la peinture mondiale et passe des condamnations, comme au jugement dernier. Vous avez peut etre vu Jackson Pollock, et vous savez ce que je veux dire par ca? Letter from Alexandre Iolas, Hugo Gallery to S.A.R; la Princesse Zeid, 15 May 1950, Zeid archives (typed without accents). Three gouaches offered to the Museum of Modern Art New York, via her daughter Shirin were refused.

25 Michel Tapié, Alfonso Ossorio, *Jackson Pollock*, Paris, Galerie Paul Facchetti, March, 1952.

26 'A quelle tendance, à quel groupe appartient Fahrelnissa Zeid? A quelle école resortissent ses oeuvres?' Chevalier 1949, unpaginated.

27 Estienne had worked with Kandinsky's widow Nina to set up the Kandinsky Prize in 1946, and prefaced the artist's *Du spirituel dans l'art et dans la peinture en particulier…* (1951). For his bitter confrontation with Victor Vasarely ('cold' abstractionist yet ex-student of Kandinsky in Budapest), see 'Académisme abstrait', in *Charles Estienne & l'art à Paris, 1945-1966*, exh. cat., Centre national des arts plastiques, Paris 1984, pp.84–5.

28 Charles Estienne, *Midi Nocturne*, Paris 1951, printed by artisans working for the Presse Marcoult in the rue des Grands-Augustins: 150 on *papier de Rives*, including ten special editions numbered I–X, each of which contained four original lithographs pulled on the Desjobert hand press – a new skill for Zeid.

29 See Émile Mâle, 'Les influences arabes dans l'art roman', *Revue des Deux Mondes*, 1923, and subsequent output; Fernand Braudel, *The Mediterranean and the Mediterranean World in the Age of Philip II*, English language edition, London 1995 (French 1949, 1962); and Henri Focillon, *The Life of Forms in Art*, New York 1948 (French 1934).

30 See André Malraux, *The Psychology of Art: 1. The Museum without Walls, 2. The Creative Act*, trans. by Stuart Gilbert, London and New York 1949 (French 1947, where *musée imaginaire*, 'imaginary museum', is not yet the 'museum without walls'.)

31 Textile-bound book with a laden grapevine on the cover, frontispiece dated '1 Juin 1951 Paris'.

32 'Et la lumière vint de l'Orient. Et voici que s'y réveille, de nouveau, la Nuit ; non pas le noir du néant, mort abstraite et froide de toutes choses, leur inexistence comme leur raturage sur la page abstraite et froide d'un livre envahi par une encre d'imprimerie avide seulement d'idées, mais cette Nuit vivante et respirante qui n'est pas l'absence du jour mais son autre côté, sa chaleur et son lieu d'origine, présents en plein midi, la grande Nuit entreclaire de Novalis et de Nerval, le royaume éclatant et funèbre où, veillent, immobiles, échangeant seulement leurs sceptres, les Déesses Mères de l'Orient et les Vierges Noires de l'Occident – étrange Midi nocturne qui réunit fabuleusement, dans le même enchevêtrement glorieux du Buisson ardent d'Aix et des vitraux de Chartres, l'arbre de Séraphine de Senlis et les palais nomades de Fahr-el-Nissa Zeid', Estienne 1951, unpaginated.

33 See Wilhelm Uhde's posthumous *Cinq maîtres primitifs: Rousseau, Vavin, Bombois, Bauchant, Séraphine*, Paris 1949 (preceding Martin Provost's film, *Séraphine*, 2008).

34 Charles Estienne (curator), *Peintres de la Nouvelle École de Paris*, Galerie de Babylone, Paris (first show opened 15 January ; second show opened 12 February. Zeid participated with Nejad, as she did for Estienne's later Salon d'Octobre).

35 Compare Hubert Juin's *Seize peintres de la jeune école de Paris* at Georges Fall, Paris, in 1956, featuring artists from Algeria, Belgium, France, Holland, Japan, Poland, Switzerland, and the United States.

36 Zeid's dynamic abstract cover for the Festival of Britain issue of *Poetry London* (no.22, 1951) demonstrates the journal's own new look and her continued presence on the London scene.

37 The Institute of Contemporary Arts archive contains the list of works from the Dina Vierny catalogue, annotated by Zeid for the London show, where *L'oiseau ibu-phoenix* became simply *The Phoenix* 1952.

38 *Inaugural Exhibition of Paintings, Coloured Indian Inks, Painted Stones, by Fahr-El-Nissa*, Lords Gallery, London, 5 June – 5 July 1957. A letter from Philip Granville (in French), dated 3 August 1957, confirmed Zeid changed titles, exhibiting paintings vertically or horizontally: *Lost and Alone* became *Still Waters* for example. He sent reproductions to the Witt Library, at the Courtauld Institute of Art, London (Zeid archives).

39 See George Butcher, 'Fahr-El-Nissa', *Middle East Forum*, December 1957, p.21.

40 Ibid., the stone sculpture reproduced.

41 Zeid exhibited with Poliakoff and James Pichette in Dina Vierny's gallery in 1955. Vierny, born in Moldavia, cultivated fellow Russian artists.

42 André Breton, *Degottex, l'épée des nuages*, exh. brochure, Galerie de l'Étoile scellée, Paris 1955.

43 'Je garde pour toujours au plus secret de mon cœur l'écho des paroles qui me sont ici venues de vous, comme un rayon émané des ces admirables géodes qui naissent et s'étendent à volonté sous vos doigts et qui est de force à mercer toutes les ténèbres.' André Breton, letter to the artist, 21 November 1955 (author's translation). Compare Breton's patronage of the proto-feminist Egyptian poet Joyce Mansour, based in Paris (*Cris*, 1953; *Déchirures*, 1955).

44 R.V. Gindertael mentions the '*Surréalisme, même*' grouping. See 'E.J.' (Edouard Jaguer) 'Le Lascaux baroque de Fahrelnissa Zeid' (unsourced press cutting involving the *paléokyrstalos* seen in the studio), undated, Zeid archives.

45 'La poésie doit être fait par tous. Non par un.' Isidore Ducasse, comte de Lautréamont (and surrealist héro) *Œuvres complètes*, ed. by Guy Lévis Mano, Paris 1938, p.327.

46 Scrap of paper with her new London address, Zeid archives.

47 The meeting in Malraux's ministerial bureau is Zeid's most powerful recollection in Olivier Lorquin's film of 1975.

48 See *Fahr-El-Nissa Zeid: Peintures 1954-1961*, exh. cat., Galerie Dina Vierny, Paris 1961.

49 'Déchiffrons, suivons les méandres de cette écriture qui revient toujours sur soi-même sans jamais conclure, comme le chant du muezzin ou un canto flamenco. Nous sommes, il est vrai, en pleine Méditerranée entre Orient et Afrique (et le ciel de Paris).' Fahrelnissa Zeid, transcription of Charles Estienne's preface, *Fahr-El-Nissa Zeid: Peintures 1954–1961*, exh. cat. 1961.

50 Unattributed letter from Sydney, to Zeid at Oakwood Court, London, 8 February 1964, Zeid archives.

51 Michel Tapié. *Un art autre où il s'agit de nouveaux dévidages du réel*, Paris 1952; Charles Estienne (ed.), *Arnal, Degottex, Duvillier, Fahr-El-Nissa Zeid, Marcelle Loubchansky, Messagier, Ossorio*, exh. cat., Galerie Craven, Paris 1953.

52 See Francesc Vicens, *Prolegomène à une esthétique autre de Michel Tapié*, Barcelona s1960; Michel Tapié, *Esthétique*, Turin 1969, etc.

53 Zeid's passionate French expresses emotions difficult to render in prosaic English: 'La vie m'a joué sa serenade et j'ai dansé autour comme une gitane/ J'ai renversé les années, en les cassant, les malsaines constructions de so'uffrance. Assoifée, affolée, à moitié aveugle, pourchassée, lamentante. J'ai accouru au brasier et le brasier m'a engloutie et c'est pour cela que je suis heureuse.' *Fahrelnissa Zeid*, exh. cat., Galerie Katia Granoff, Paris 1969, unpaginated.

54 Katia Granoff: 'Elle est éprise de grandeur et d'absolu comme ce roi, descendant d'Alexandre, qui fit ériger il y a deux mille ans à Nemrut-Dag un panthéon mi-grec-mi-persane où se dressent, aux pieds des statues géantes, des têtes colossales.' Zeid's poem, in which eyes are described as 'disques des temps perdus' also appears in *Fahrelnissa Zeid: Portraits et peintures abstraites*, exh. cat., Galerie Katia Granoff, Paris 1972, (with a text by René Barotte), unpaginated.

55 With thanks to Olivier Lorquin for affording me his time, 14 September 2016.

56 Only posthumously could mother and son appear together, in Cem İleri (ed.), *Fahrelnissa and Nejad: Two Generations of the Rainbow*, exh. cat., Istanbul Modern, 2006 (curator: Haldun Dostoğlu).

57 Noha Hosni (ed.), *Trois femmes peintres: Baya, Chaïbia, Fahrelnissa*, exh. cat., Institut du monde arabe (EDIFRA), Paris 1990; see also Rita El Khayat, *La femme artiste dans le monde arabe*, Paris 2011. Chaïbia Talal's deliberate choice of a 'child-like' style close to the 1950s CoBrA group, and Baya Mahieddine's participation in the Galerie Maeght's show *Les Mains Éblouis* in 1947, and her recognition by Breton and Picasso should be recognised. See André Breton, 'Baya', in *Derrière le miroir*, Galerie Aimé Maeght, Paris 1947 (translation by Ranjana Khanna and Julie Singer, in *Art History*, vol.26, no.2, 2003, p.287).

58 See Sarah Neel-Smith, 'Fahrelnissa Zeid in the Mega-Museum. Mega-Museums and modern artists from the Middle East', 14 July 2016, http//:www.ibraaz.org/essays/161/.

59 Edward Said's influential classic, *Orientalism* (1978), might be reinterrogated here. See *Modernités plurielles, de 1905 à 1970*, exh. cat., Centre Pompidou, Paris 2013, etc.

60 *L'École de Paris Turque*, Musée du Montparnasse/ La Villa Vassilieff, Paris, 2010, including the work of Fikret Mualla, Nejad Devrim, Hakkı Anlı, Mübin Orhon, Abidin Dino, Remzi Raşa, Selim Turna, Ambert Bitran, Avni Arbaş (curated by Gaya Petek for the Saison turque à Paris.)

61 See my essay 'New Images of Man. Postwar Humanism and its challenges', in Okwui Enwezor (ed). *Postwar: Art between the Pacific and the Atlantic, 1945-1965*, exh. cat., Haus der Kunst, Munich 2016, pp.344-9.

45
Untitled n.d.
Mixed media on paper
72 × 53
The Raad Zeid Al-Hussein Collection

46
Untitled n.d.
Mixed media on paper
72.4 × 53.1
The Raad Zeid Al-Hussein Collection

47
Idols n.d.
Mixed media on paper
31.6 × 38.5
The Raad Zeid Al-Hussein Collection

48
Untitled 1971
Mixed media on paper
22.9 × 14.6
The Raad Zeid Al-Hussein Collection

49
Untitled 1963
Mixed media on paper
28 × 21.2
The Raad Zeid Al-Hussein Collection

50
Untitled 1963
Mixed media on paper
29.2 × 22.9
The Raad Zeid Al-Hussein Collection

51
Untitled n.d.
Mixed media on paper
28.5 × 22
The Raad Zeid Al-Hussein Collection

52

Bedouin Women (Towards Abstract)

c.1950

Mixed media on paper

58.4 × 45.7

The Raad Zeid Al-Hussein Collection

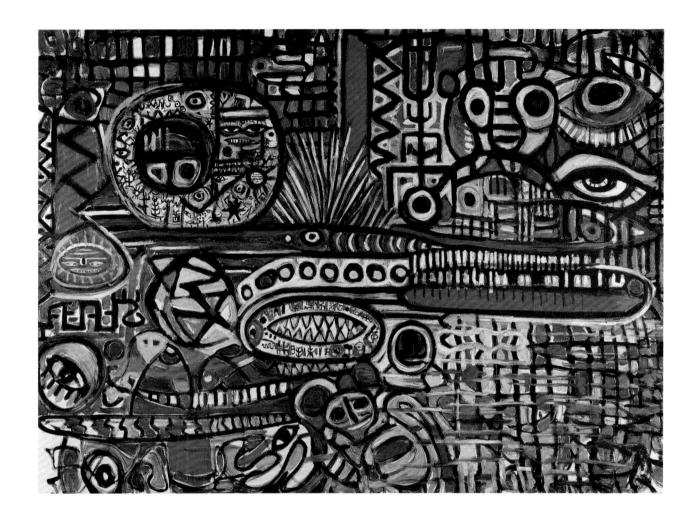

53
Untitled 1954
Oil paint on canvas
200 × 279.9
Private collection

54
The Reverse 1964
Oil paint on stretcher and canvas
132 × 162
Demiroren Collection

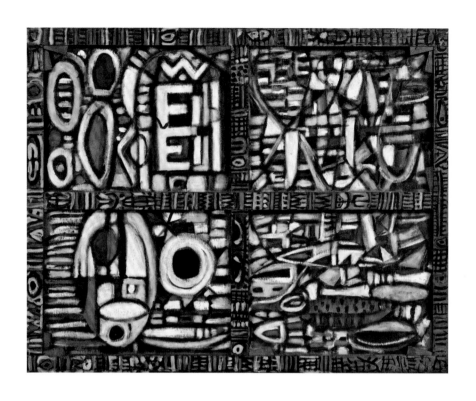

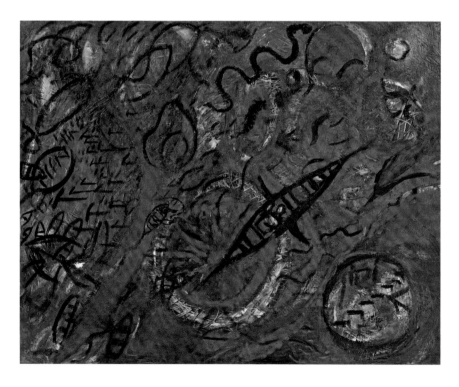

55
Shining c.1955
Irisations
Oil paint on canvas
65 × 54
Ceyda and Ünal Göğüş Collection

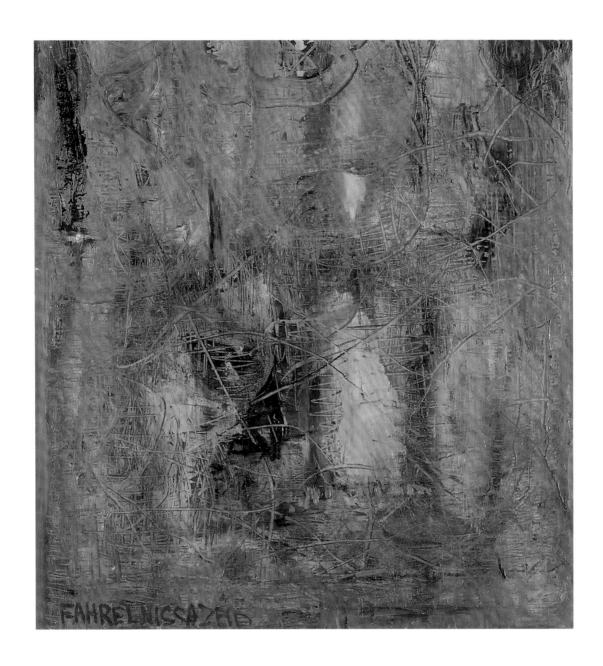

56
Fire before 1964
Oil paint on canvas
75 × 71
Ceyda and Ünal Göğüş Collection

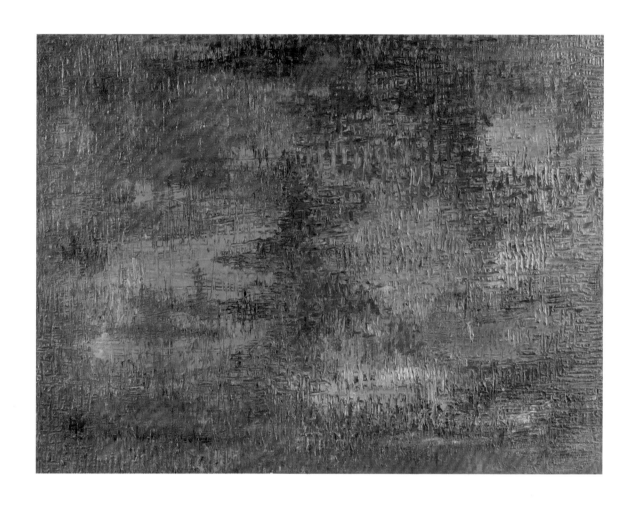

57
Lost Horizon 1947
Oil paint on canvas
76.5 × 101.5
Öner Kocabeyoglu

114

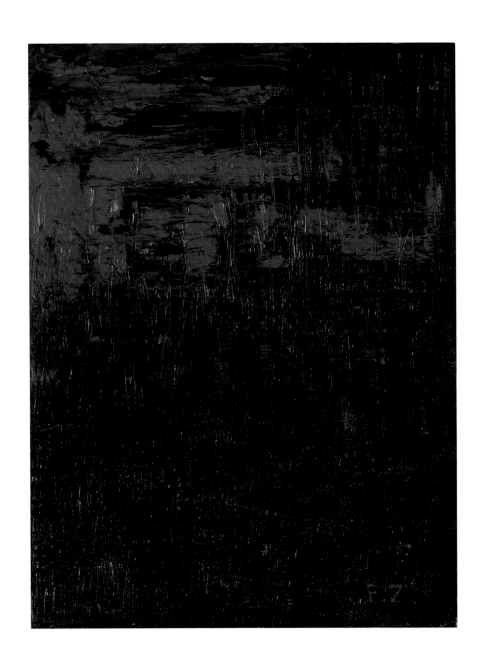

58
Nightmare 1958
Oil paint on canvas
102 × 76
Private collection

59
Break of the Atom and Vegetal Life 1962
Rupture de l'atome et vie végétale
Oil paint on canvas
210 × 540
Z. Yildirim Family Collection

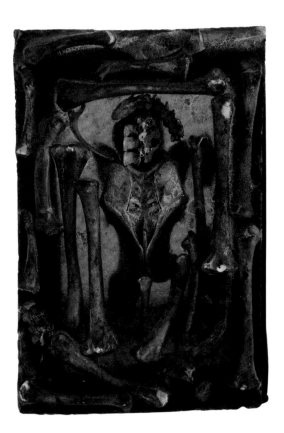

61
Paléokrystalos c. late 1960s
Bones, paint and polyester resin
28.5 × 17.5 × 2.5
The Raad Zeid Al-Hussein Collection

62
Aquarium 1967
Bone, paint and polyester resin
37 × 30.5 × 4.5
The Raad Zeid Al-Hussein Collection

63
Paléokrystalos c.late 1960s
Bone, paint and polyester resin
30 × 32 × 6.3
The Raad Zeid Al-Hussein Collection

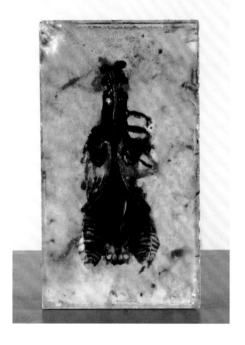

64
The Man of All Times 1967
L'Homme de Tous Temps
Bone, paint and polyester resin
45 × 39.5 × 33.8
The Raad Zeid Al-Hussein Collection

65
Paléokrystalos 1969
Bone, paint and polyester resin
30 × 17.5 × 6
Istanbul Museum of Modern Art Collection
Nermin Abadan Unat Donation

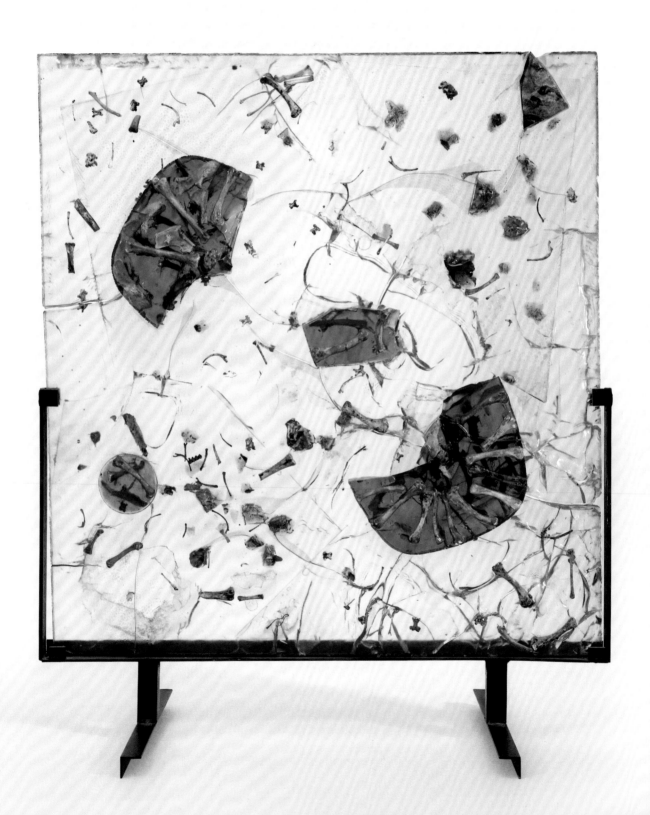

66
Moon Drops 1967
Bones, paint and polyester resin
87.5 × 83.3 × 2.5
The Raad Zeid Al-Hussein Collection

67
Paléokrystalos c. late 1960s
Bones, paint and polyester resin
90.5 × 30
The Raad Zeid Al-Hussein Collection

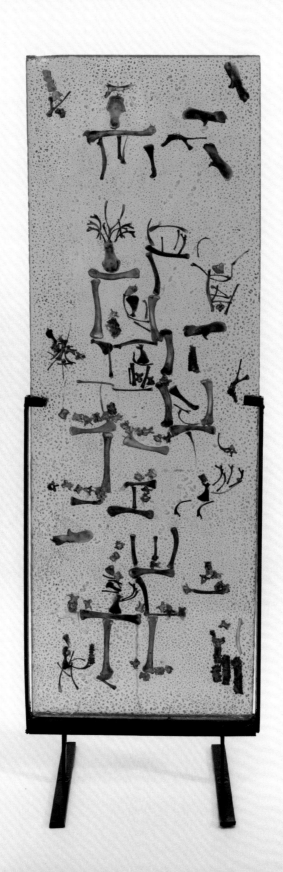

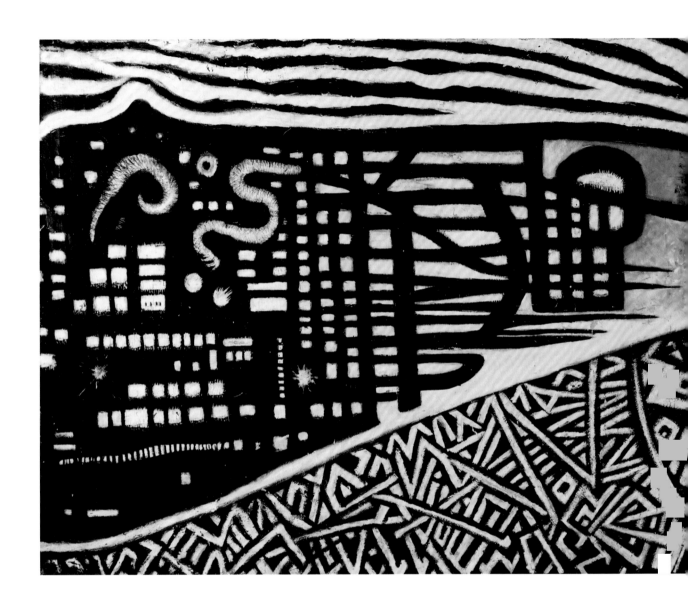

68
**The Fight of the Moon and
the Astronaut** 1968
L'intrus, la Lune et le Cosmos
Oil paint on canvas
218 × 515
Private collection, Qatar

69
Puncta Imperator ('Sea Cave') 1963
Caverne Maritime
Oil paint on canvas
164.8 × 210.5
The Raad Zeid Al-Hussein Collection

70
London ('The Firework') before 1972
Le Feu d'Artifice
Oil paint on canvas
178 × 210
Berrak and Nezih Barut Collection

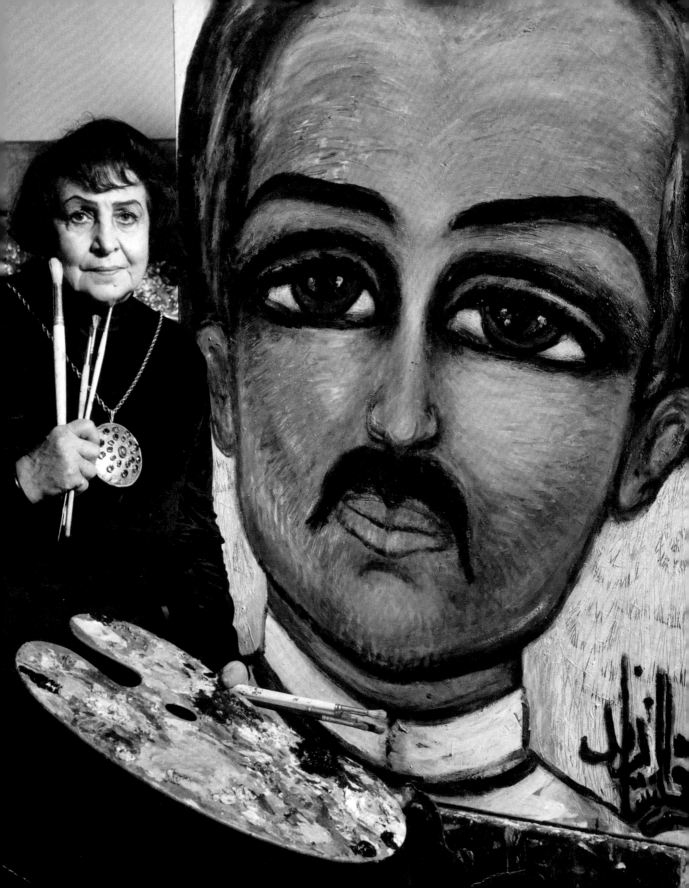

The Late Style

ADILA LAÏDI-HANIEH

'Late style' refers to a stylistic quality possessed by works created late in an artist's career, after decades of creative productivity. This notion of a late output by artists renewed with youthful energy in the face of impending mortality was Edward Said's amplification and expansion of a thought developed by Theodor Adorno writing on Beethoven's third period compositions, which Adorno saw as full of irresolution and eccentricity. These peculiarities of style do not necessarily suggest closure and quiet resolution but rather 'intransigence, difficulty, and unresolved contradiction ... nonharmonious, nonserene tension' and a 'deliberately unproductive productiveness'.[1] Said's examples do not include visual artists, but he does consider, *inter alia*, Constantine Cavafy's refusal to write about the present, Richard Strauss's old-fashioned operas, with their eighteenth-century allusions, Glenn Gould's abandoning live audience performances, and Luchino Visconti's resistant, anachronistic film adaptation of *The Leopard* (1963), along with its 1958 source novel, by Giuseppe Tomasi di Lampedusa.[2] Said defines the notion of timeliness in art and in life as appropriateness to certain stages of life, and the lack thereof at other periods.[3] Accordingly, he explains 'lateness' as 'the idea of surviving beyond what is acceptable and normal'. However, this lateness is not an apotheotic transcendental shift, but a being '*for itself*, its own sake, not as a preparation for, or obliteration of something else. Lateness is being at the end, fully conscious, full of memory, and also very ... aware of the present.' This late style is *in*, but oddly *apart from*, the present.[4] Above all, any absences and silences in late style may not be explained away by the weaknesses of old age.

Fahrelnissa Zeid relocated to Amman, Jordan, at the age of seventy-four, embarking on the 'most creative, productive and rewarding period of her life', according to her daughter Shirin.[5] Having decided to teach art, Zeid proceeded with vigour to find students and to mentor and promote them over the next fifteen years. In her own practice, she continued her focus on portraiture, which she had reprised in the 1960s, while her teaching revolved around abstraction. The portraits Zeid made in Amman in the late 1970s and 1980s are 'full of memory' of her 1940s and 1960s portraits, yet they constitute a departure from them.[6] The few extant 1940s portraits (for example, *Self-Portrait* 1944 (no.1), *Emir Zeid* 1944 (no.74) and *Emir Raad* early 1940s

FIG.31
Zeid with *Crown Prince Hassan* 1968,
Paris, before 1975
The Raad Zeid Al-Hussein Collection

fig.32) manifest a tension between her consummate *beaux-arts* academic instruction, and her expressionist sensibilities. These works have a realist workmanship, in the naturalistically rendered flesh of the figures, the proportion of volumes and the inclusion of background decor. The expressionist tendency is manifest in the exaggerated expressivity of the figures, especially in their commanding gaze.

Zeid's 1960s and 1970s portraits fall into two categories: the bust and half-length social portraits of her gallerists, their families and her casual friends; and the close-up, full-face psychological studies of people to whom she was closest. The latter include curators and art critics such as Charles Estienne (no.72) and Maurice Collis (no.75) and family members such as her husband, Prince Zeid Al-Hussein, whom she painted many times, and her son Prince Raad. In these portraits, the eyes mirror the sitters' personalities, as she perceived them, the flesh of their faces becoming abstract surfaces vigorously layered with improbable colours of similar and sometimes opposed range, scratched to reveal chromatic palimpsests.

In Amman, Zeid also selected sitters from her circle of friends, family and students. The Amman portraits, however, reveal a purgation – an exercise in pure painting in her figurative expressionist vein that juxtaposes chromatic simplification with a subject's character. Focusing her innovative and intellectual energies on her teaching, Zeid turned to portraiture as a pure exercise of painting '*for itself*', and for her own sake.

Zeid had sold her studio apartment in Paris and left for Amman in 1975, five years after the passing of her husband, and she lived and worked there until her death in 1991. She chose Jordan for her new home so as to be near her son, Prince Raad, who was chamberlain of the royal court there. With his wife, Princess Majda, they had a growing young family that would provide companionship and an anchor against the tides of loneliness. Once there, undaunted by old age and illnesses, Zeid continued to exhibit both in Jordan and Europe, and to receive family members and an expanding and varied group of acquaintances and friends. She recreated the familiar cultural and social worlds she had known previously in

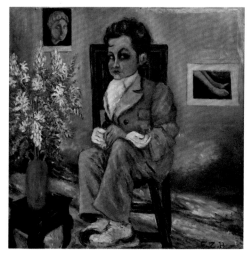

FIG.32
Emir Raad early 1940s
Oil paint on canvas
97.5 × 97.5
The Raad Zeid Al-Hussein Collection

her life, and reproduced in her Amman home the cluttered aesthetic of her successive studios in Istanbul and Europe. All of the walls and ceilings, including those of the bathrooms and kitchen, were covered with her watercolours, lithographs, ink and gouache drawings and exhibition posters, and by small and large abstract and figurative oils from her diverse periods of work. The house was a panoramic, decorative, chronological sedimentation.

Late style as bifurcation

Zeid's output in Amman is far from recalling Beethoven's late style in its alienation and obscurity, or Adorno's irreconciliation with administered society. It is not so much that her painterly practice exhibits late style. Rather, her artistic outlook exhibits late style as it diverges into anachronistic directions. Since the 1940s, Zeid had single-mindedly focused on creating, promoting, perfecting, renewing and transcending her artwork. In Amman, she breaks the notion of 'art work' into two paths: painting and teaching. Her artistic outlook comes to exhibit a bifurcated energy.

She projects herself with great urgency into the future by teaching, and, with one or two exceptions, chooses to mentor only adults who have never painted before. She designates them her students, encourages them intellectually and promotes their work. Meanwhile, her own artistic practice is an irregular combination of circular return, accumulation and purification: she returns to the figurative portraiture on which she embarked as an adolescent, modified by a simplified expressionism. Zeid therefore, exhibits lateness as being out of her time: she is both in the future and in a revisited past – 'unfashionable', and 'in, but oddly *apart* from the present'.[7]

In her teaching, also, Zeid was both *in*, and *apart* from the present. She did not introduce her new students to contemporary art trends of the 1970s and 1980s and she kept her distance from late-modern art developments in the Middle East. There, three movements largely dominated: an engaged, committed political sensibility; nativist and primitivist syntheses aiming to join classical and folkloric art forms with contemporary painting of the type she

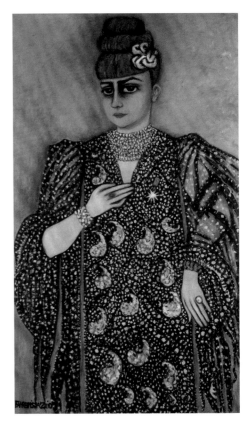

FIG.33
Katia Granoff 1971
Oil paint on canvas
193 × 112
Collection Larock Granoff, Paris

had already known with the d Group in Turkey, but interest in which she did not share; and calligraphic abstraction. Instead, she focused in her teaching on what was, for her, the kernel of self-expression: abstract art. In typical late style, her teaching was ahead of its time, setting aside academic pedagogies to foster self-expression and introspection.[8]

Even before leaving Paris, Zeid had decided that she would devote the next period of her career to teaching art.[9] As soon as she arrived in Amman she began giving art classes, in her son's house, to a few isolated students, but, after moving into her own home, she gathered a growing number of amateur artists around her and held regular classes with a core group of students, most of whom had cosmopolitan backgrounds. She taught them the techniques of painting and also included the history of art, philosophy and her own views on life and art in an informal way. In 1976, she made her teaching official by legally registering The Royal National Jordanian Institute Fahrelnissa Zeid of Fine Arts, although the institute did not grow beyond the confines of her home, and teaching was tuition-free. Existing students were to introduce additional pupils over the years.

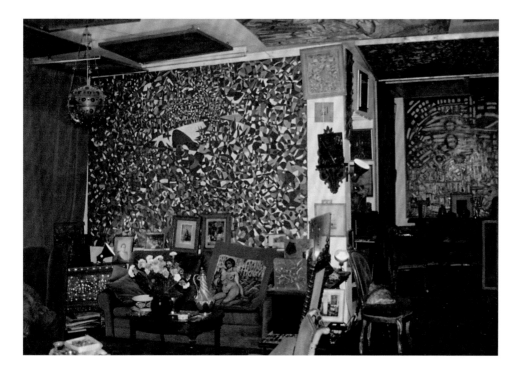

FIG.34
Zeid's home, Amman, 1991
Yahşi Baraz Archive

Zeid started off with the first group of students, who met and worked collectively at her home studio until 1984, by giving them a canvas and asking them to paint either her portrait or an abstract work. They would then meet weekly to work in her studio, complete their paintings in their homes, and return for a group critique and discussion of the works. As the number of students grew, Zeid could no longer accommodate them in her small studio, so they would generally paint at home and bring their works individually for review and critique.[10]

The teaching itself was free of academicism. Students were mainly asked to express themselves directly on canvas. Zeid did not give drawing lessons but focused on explaining and teaching composition, volume and perspective. The point was to begin with depth before form. She instilled in students the need to consider both the formal/visual and the inner/spiritual dimensions of a work, stressing the qualities of balance, precision, volume or clarity, for example, alongside the expression of dreams, longings, visions, space or solitude. Zeid also emphasised the need for a total liberation of instincts, the strengthening of the imaginary and the importance of seeing beyond material forms to attain abstract purity. Her constant reminder to her students was the very modernist injunction to un-learn: 'you must forget what you know because what you know is what you have learned, but what you do not know is what you really are.'[11]

The major group exhibition that Zeid held in 1981, in Amman, with twelve of her students, punctuated her teaching. The exhibition was unprecedented in the region. Its structure – a teacher exhibiting with her students – was unique, and the scale of the works presented was highly unusual, especially because the exhibition included several of Zeid's monumental abstract paintings. No hall could accommodate the show, so the largest local auditorium was converted into an ad hoc exhibition space. The exhibition was extended, received wide coverage in the press and was noted by local critics for clashing with the art seen at the time in Jordan. After the exhibition, Zeid encouraged her students to develop their careers and exhibit independently, which a few of them did, both in Jordan and abroad.[12]

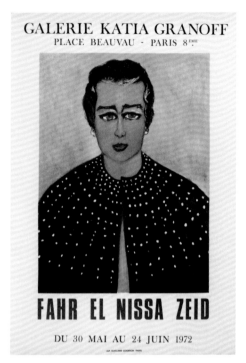

FIG.36
'Fahr El Nissa Zeid' exhibition poster,
Galerie Katia Granoff, Paris, 1972
The Raad Zeid Al-Hussein Collection

Portraits

Zeid began drawing and painting portraits in her adolescence and, although her work became increasingly abstract from the end of the 1940s onwards, she continued to create figurative drawings privately. Quick, precise and dramatic self-portraits and figurative studies fill the sketchbooks and diaries she kept for eight decades. She stated that she saw no difference between abstraction and figuration. Rather, for her: 'One cannot really separate figurative and abstract on the technical level … Everything made by the hand of man, any creation is a manifestation of the spirit.'[13]

Zeid's gradual return to painterly portraiture in the 1960s was in tune with the wider zeitgeist, as a few artists in her Paris and London environments (Bernard Buffet, Francis Bacon and Lucian Freud) began a revival of the genre. However, she did not include figurative works alongside the abstract paintings, lithographs and *paléokrystalos* sculptures she presented in her 1964 and 1969 exhibitions in Istanbul, Ankara and Paris. Zeid publicly presented the portraits she made later in life for the first time at Galerie Katia Granoff, Paris, in 1972. Critics lauded the works for their freshness and unexpected psychological take on well-known Parisian art-world figures. This staggered production of large-scale abstract paintings in the 1950s and 1960s, of *paléokrystalos* sculptures and looser abstract paintings in the 1960s, and the carefully made decisions of what to exhibit and when, show Zeid's concern for timelines and renewal. Presenting paintings made in the 1960s as recent work in 1972 was a demonstration of lateness as innovation, and of anachronism as timeliness. That exhibition, her last solo show in Paris, ushered in a new chapter in Zeid's career, which began in earnest a few years later in Amman in the bifurcated form discussed above: innovating via teaching, and reprising portraiture in her own painterly practice.

Zeid's approach to portraiture gradually downplayed naturalistic resemblance, shifting between two general trends: she favoured expressive psychological studies from the 1960s to 1972, and thereafter, in Amman, stressed surface properties and studies of form and colour. There, over fifteen years, she produced a considerable output, which was made at great speed despite her advancing age and ailments, and has been largely unaccounted for. She shifted to a slightly smaller

scale, de-emphasised full-canvas facial portraits in favour of busts or three-quarter-length works, and added in simple monochrome backgrounds. She developed a highly recognisable individual style, within which sitters tend to resemble each other, but are distinguishable: calm, seemingly static compositions prevail, in hieratic portraits rendered in planar frontality, where the juxtaposition of highly saturated and contrasting planes of colour conveys dynamism. Zeid compensates for the flatness of the portraits by *cloisonnisme* – shaping colour fields with a black outline – in accordance with her modernist disregard for three-dimensionality and visual continuity. Another characteristic of the portraits was their systematic featuring of a small error in perspective, volume or finishing, to underscore Zeid's belief that portraiture ought to be free from reproducing physical appearance and should instead 'give life'.[14] Above all, these late works manifest Zeid's focus on pure painting, meeting her own visceral need to paint. The considerable number of works produced, their quick realisation, their flattened perspective, abbreviated textures and forms, and simple chromatic juxtapositions show that they were the result of her lifelong need to paint, first and foremost. She now channelled her more innovative artistic endeavours and intellectual process into her teaching.

The full-length portraits she painted in Amman were, notably, of family members and the students she was closest to – Hind Nasser and Suha Shoman – sometimes shown in regional folk dresses and with the paintings frequently including allusions to events in their lives.

Late portraits

Zeid's portraits from her Amman period broadly represent the traits of her painterly late style in the generic and simplified features of the sitters. To illustrate this point, three portraits will be discussed in detail, a painting of artist Suha Shoman; another of Shoman's husband Khalid; and a third of her older sister, noted Arab-American artist Nabila Hilmi. The three portraits were not commissioned, but rather painted at the artist's request, as is the case with most of Zeid's late portraits. Even though these paintings were all completed in the same period and bear the general features of her Amman portraits,

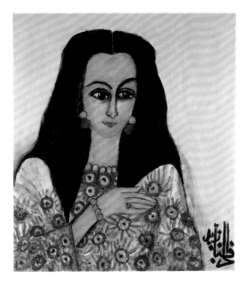

FIG.37
Nabila c.1980s
Oil paint on canvas
100 × 90
The Khalid Shoman Collection

their treatment varies, thus visually manifesting 'non-harmonious, nonserene tension'.

Suha 1983 (no.80) was painted on the spur of the moment. Seeing Suha Shoman enter her home wearing a new shawl, Zeid was struck by its shape and colour, and decided to paint her there and then. Shoman and Zeid had a strong personal, artistic and intellectual rapport and, while Zeid mentored the younger Shoman during her life, Shoman has worked to promote Zeid's legacy locally and internationally since her death.[15] Shoman's casual entrance into Zeid's house wearing a new shawl is transformed, in this painting, into an archetypal, three-colour composition, intensified by the strong, continuous black outlines of the shawl's folds, and relieved only by Shoman's pensive gaze. The quick pace at which the painting was completed is evidenced in the short brushstrokes of the depthless background. However, Shoman's closeness to Zeid perhaps accounts for the subtle colouring and finished brushwork of the hair and face. This impulsive, minimal work reflects Zeid's attitude to portraiture in Amman as a response to emotional and visual stimuli, and as a realisation of her instinctive desire to paint.

Khalid Shoman 1984 (no.79) is another three-quarter-length portrait finished after one sitting, but deploys a range of contrasting effects. The sitter is represented with a combination of mature mane, youthful attire and intense gaze. The vivid yellow background is contrasted with a modulated rendering of the sitter's white sweater, with gradations of low-saturation colours to create shading and convey the lightness of the fabric. The carefully rendered brow bone and eyelids frame an intense gaze, contrasting with the smooth, subtle blending and shading elsewhere on the face, which conveys volume, but also vulnerability. The details of the face and sweater draw the viewer to the sitter's torso and face and away from the stark background. This makes for a casually intimate portrait, manifesting the close relationship between the artist and her subject, which is in sharp contrast to how the sitter was otherwise perceived, as one of the most important Arab bankers and philanthropists of his time.

In *Nabila*, a bust portrait from the 1980s, anatomical elements are exaggerated (Hilmi's face and hair are elongated) and there is a simplification of line. The subject's hair is painted a flat, heavy black,

framing a face roughly finished with short brushstrokes. The sitter's intense gaze anchors the rest of the face, which is roughly painted. The pared down and pale background of the upper part of the painting contrasts with the busy rendering of the clothes' designs in the lower part. Zeid's distinctive, tightly assembled motifs are now flowers in Nabila's dress, conveying a vibrant decorative effect belying the overall quietness of the painting. They resemble radiating asters about to orbit out of the composition. The gold and red detailing of the jewellery links the lower and upper elements of the composition. This seemingly simple portrait is thus a visual balancing of tendencies from Zeid's different stylistic epochs: the eschewing of realistic detailing, simplified portraiture, busy patterns and chromatic vividness.

Late style assessed

After 1975, when Zeid relocated to Amman, she began to exhibit less. The exhibitions that did take place in the last fifteen years of her life were either retrospectives that focused on her abstract works or group exhibitions organised with her students. As such, the significant number of portraits Zeid made during this time were given less attention. Consequently, this period of the artist's career has been the object of elision or of dismissive assessments, rather than of engaged evaluation and contextual scholarship. For example, one writer saw this production as manifesting 'aesthetic barrenness' and 'aesthetic de-skilling'.[16] Another asserted that Zeid had turned her 'back … on the West. Because these images of her close relatives and friends have practically no foundation in the art history that is familiar to us and that leads us to representations of Egyptian sarcophagi and passing by Persian portraits.'[17] Such arguments are part of a chain of othering evaluations of Fahrelnissa Zeid, as a painter of fantastically oriental dreamscapes and little else. These assertions have no verifiable foundation. Zeid's experience studying at the Académie Ranson in 1928 led her to forego the skills she accumulated in her *beaux-arts* education in Istanbul. Under the influence of Roger Bissière, she abandoned classicist realism in favour of a free expressionist style.

Furthermore, there is no indication in Zeid's writings that she was under the stylistic influence of a culturalist atavism. In fact, Fayum mummy portraits are, above all, Greco-Roman naturalist representations, while Zeid's Amman portraits have less in common with the controlled precision of Iranian miniatures than with twentieth- century expressionist exaggeration and chromatic abandon.

In her late style, therefore, Zeid recalls the styles of Strauss, Lampedusa and Visconti. In as much as 'each … makes of lateness or untimeliness, and a vulnerable maturity, a platform for alternative and unregimented modes of subjectivity, at the same time that each … has a lifetime of technical effort and preparation', and could 'play off the great totalising codes of twentieth-century Western culture … The one thing that is difficult to find in their work is embarrassment, even though they are egregiously self-conscious and supreme technicians. It is as if having achieved age, they want none of its supposed serenity or maturity.'[18]

1 Edward Said, *On Late Style: Music and Literature against the Grain*, New York 2007, p.6.
2 Edward Said saw Adorno's position as, above all, theoretical: he hailed, in Beethoven's last period, a constitutive, un-synthesised fragmentary-ness as prototypical of modern music's future intransigent aesthetic form. He may have also seen in it an implicit mirror of his own, lifelong, contrapuntal and oppositional energy to a number of ideologies and political and economic dispensations. Said 2007, p.19.
3 Ibid., p.5.
4 Ibid., pp.13, 14.
5 Shirin Devrim, *A Turkish Tapestry: The Shakirs of Istanbul*, new edn, London 1996, p.234.
6 Said 2007, p.14.
7 Ibid., pp.23–4.
8 Given Zeid's considerable energies, even this bifurcated path was not definitely set. She decided in the mid-1980s to learn, and teach her students, stained-glass painting, a practice many of her contemporaries in the Nouvelle École de Paris had taken up in the form of public commissions. She invited a teacher from Paris to live in Amman and teach. Both she and her students learned the techniques of cutting glass and pouring chemicals and firing them, and Zeid exhibited these works in Amman. They could not continue the practice, however, given the difficulty and expense of sourcing the necessary materials.
9 As she states in a documentary made by Olivier Lorquin prior to Fahrelnissa Zeid leaving Paris for Amman. *Fahrelnissa Zeid à Paris 1949–1975*, Paris 1975, 43 min, 24 sec.
10 Her students included (in alphabetical order): Princess Alia, Jeanette Joumblatt, Adila Laïdi, Princess Majda, Rabab Mango, Hind Nasser, Nawal Qattan, Leila Rizk, Ufemia Rizk, Janset Shami, Suha Shoman, Rula Shukairy and Alia Zubyan.
11 Fahrelnissa Zeid, *Fahrelnissa Zeid and her Institute*, exh. cat., Royal National Jordanian Institute Fahrelnissa Zeid of Fine Arts, Amman 1981, p.23.
12 These were Hind Nasser, Ufemia Rizk, Suha Shoman and Rula Shukairy.
13 Fahrelnissa Zeid, *The Centenary of Fahrelnissa Zeid*, Amman 2001, p.27. Translation from French, author's own.
14 Zeid 1981, p.20.
15 Notably via Darat al Funun, the art foundation that Shoman founded in 1988.
16 Ulrich Loock, 'Transitions and Translations', in Sarah Rogers and Eline van der Vlist (eds.), *Arab Art Histories: The Khalid Shoman Collection*, Amman 2013, pp.315–20, 316–17.
17 Wolfgang Becker, 'Fahr El Nissa Zeid et l'École de Paris', in *Fahr El Nissa Zeid: Entre l'Orient et l'Occident*, exh. cat., Neue Galerie-Sammlung Ludwig & Institut du Monde Arabe, Aachen & Paris 1990. Translation from French, author's own.
18 Said 2007, p.113.

71
Divine Protection 1981
Oil paint on canvas
206 × 130
The Khalid Shoman Collection

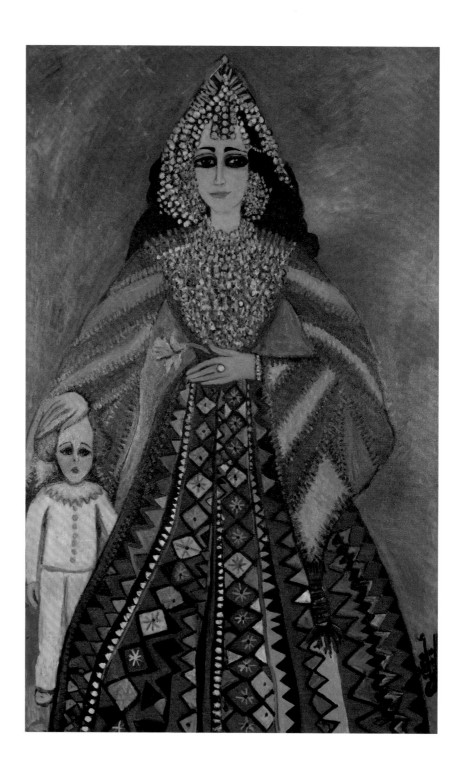

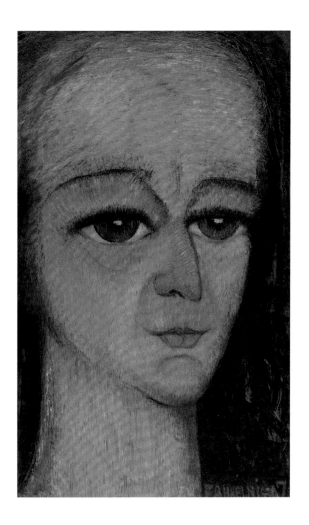

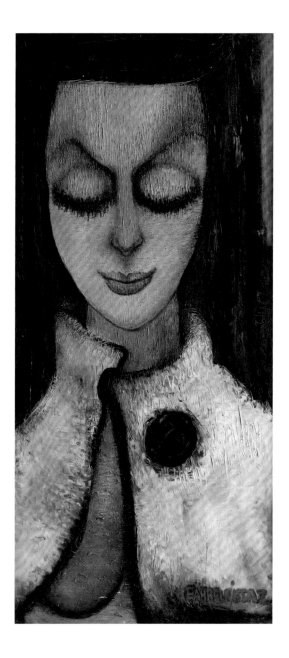

72
Charles Estienne c.1964
Oil paint on canvas
138 × 85
Musée d'Art Moderne
de la Ville de Paris

73
Iris Clert 1965
Oil paint on canvas
174 × 80
Private collection

74
Emir Zeid 1967
Oil paint on canvas
181 × 139
The Raad Zeid Al-Hussein Collection

142

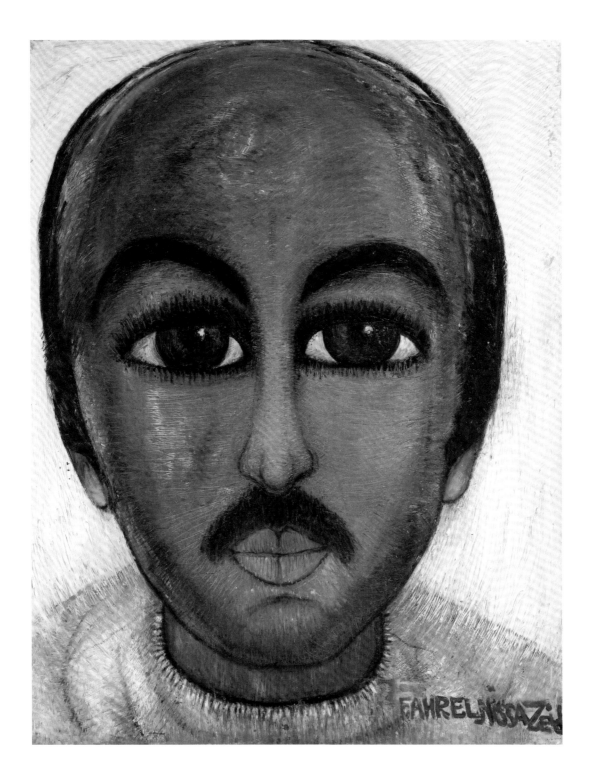

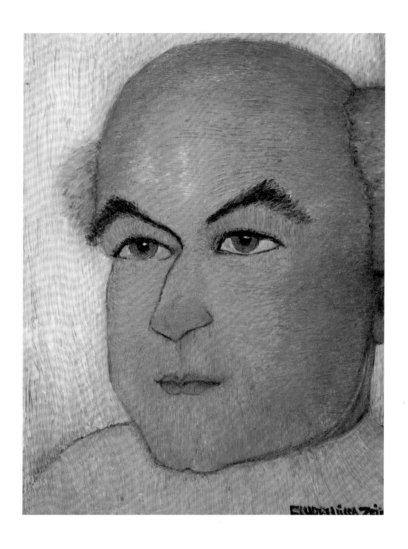

75
Maurice Collis 1968
Oil paint on canvas
90.2 × 69
The Raad Zeid Al-Hussein Collection

76
René Barotte 1970
Oil paint on canvas
126.6 × 95.5
The Raad Zeid Al-Hussein Collection

144

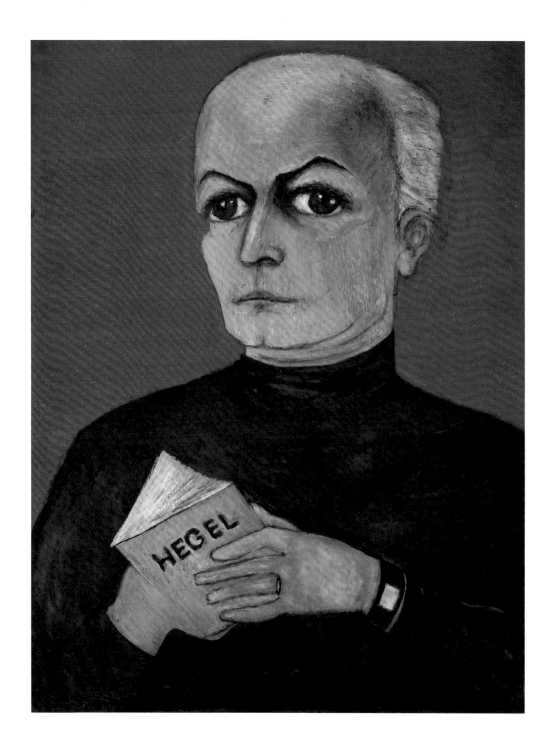

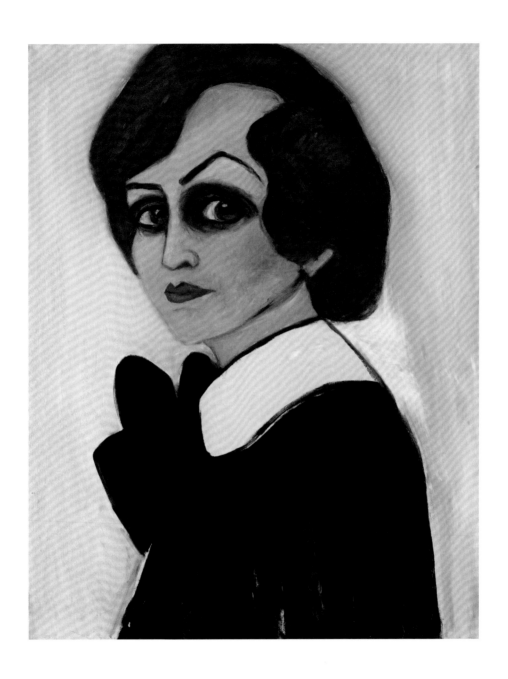

77
Self-Portrait c.late 1970s
Oil paint on canvas
115 × 89.5
DEMSA Collection

78
Rose Larock Granoff 1971
Oil paint on canvas
128 × 95
Collection Larock Granoff, Paris

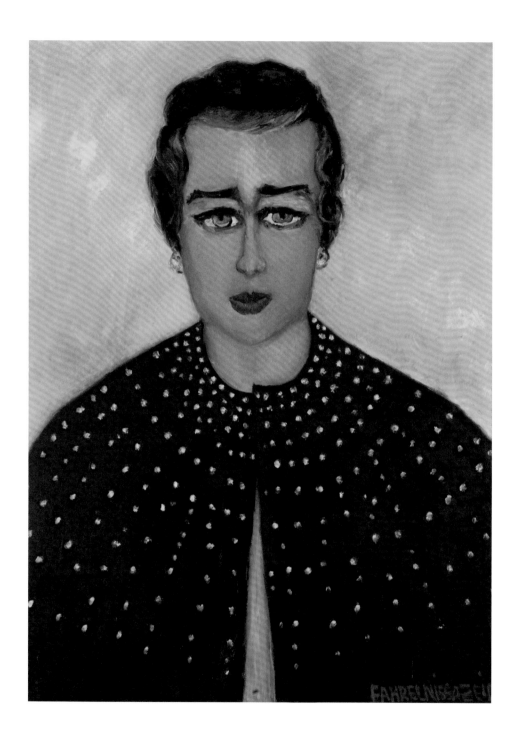

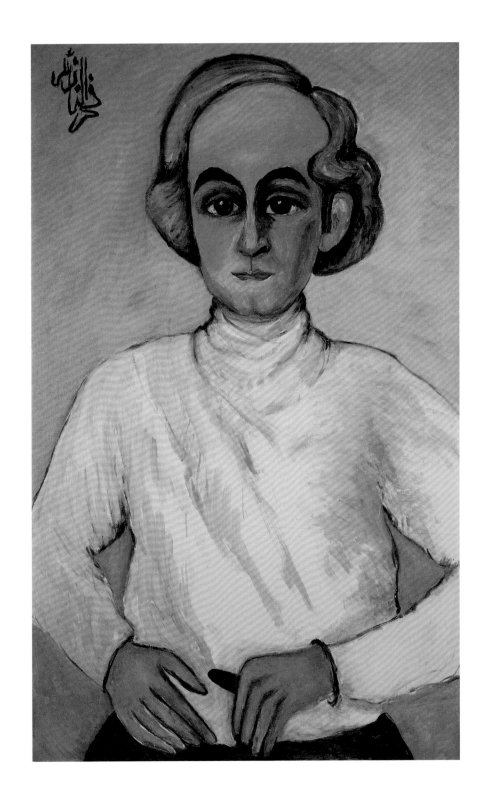

148

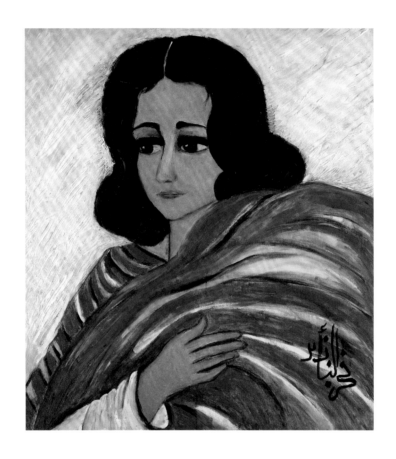

79
Khalid Shoman 1984
Oil paint on canvas
179.5 × 112
The Khalid Shoman Collection

80
Suha 1983
Oil paint on canvas
100 × 90
The Khalid Shoman Collection

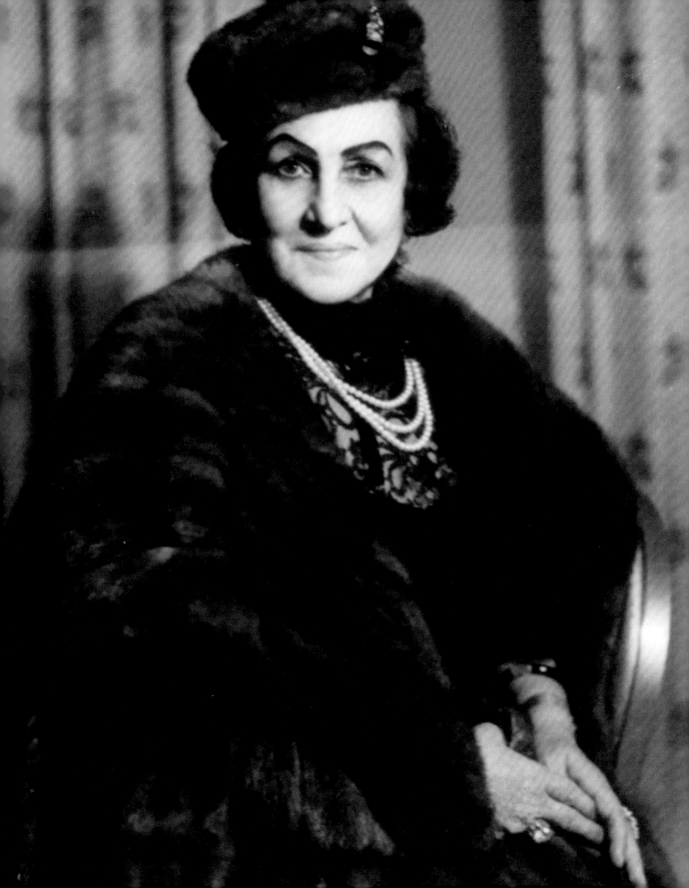

Chronology

NECMI SÖNMEZ

1901

6 December – Fahrelnissa Zeid is born Fahrünnisa Şakir into an aristocratic Ottoman family on Büyükada island in the Sea of Marmara, near Istanbul. She is Şakir Pasha and Sara İsmet Hanım's fifth child. Cevat Pasha, Fahrünnisa's uncle, was Grand Vizier to the Sultan in the late nineteenth century – the most important administrator in the Ottoman Empire. While occupying this role, Cevat appointed his brother Şakir as the ambassador to Greece, where he met Fahrünnisa's (Cretan) mother.

Fahrünnisa and her siblings are raised in a household where art, music and literature are appreciated and education is highly valued. As a child, Fahrünnisa admires her mother's paintings on silk and her older brother Cevat's drawings. Later, this same brother moves to a fishing village in Bodrum and becomes a renowned author, writing under the pseudonym 'Fisherman of Halicarnassus'. Their sister, Aliye Berger, meanwhile becomes a leading engraver

in Turkey, holding legendary salons with authors, playwrights and artists in her studio in Beyoğlu, on the European side of Istanbul. Later, Fahrünnissa's niece, Füreya Koral, makes a name for herself as a ceramicist in Turkey.

1914

The early twentieth century brings rapid social and cultural change to Istanbul, the capital of the Ottoman Empire. Before the outbreak of the First World War, numerous cultural institutions and educational organisations are established. Among these is the İnas Sanayi-i Nefise Mektebi (Academy of Fine Arts for Women), which creates opportunities for aspiring women artists and arts educators and becomes an important centre for the emancipation of women in Turkey.

June – Fahrünnisa's father is shot dead in unexplained circumstances. Her brother Cevat is tried and convicted of manslaughter and sentenced to fourteen years in prison.

FIG.39
The artist (seated on the left) with her family. Her father, Şakir Pasha, is at the top centre, Büyükada, Istanbul, c.1910
The Raad Zeid
Al-Hussein Collection

FIG.38
Zeid, New York, 1949
The Raad Zeid
Al-Hussein Collection

28 June – Archduke Franz Ferdinand of Austria, heir to the throne of Austria-Hungary, is assassinated by Yugoslav nationalist Gavrilo Princip in Sarajevo, triggering a diplomatic crisis in the region. One month later, the Austro-Hungarians declare war on Serbia. As Russia mobilises in support of Serbia, Germany invades Belgium and Luxembourg before moving towards France, leading the United Kingdom to declare war on Germany.

August – The Ottoman Empire joins the Central Powers (Germany and the Austro-Hungarian Empire).

28 October – The Ottoman Empire formally enters the First World War, with the bombing of Russian ports in the Black Sea.

September–December – Fahrünnisa is educated at Notre-Dame de Sion, a French convent school in Istanbul. Although short-lived, her exposure to the French language and culture during this period has a lasting influence.

FIG.40 (left)
The artist with İzzet Melih Devrim on their honeymoon, Venice, 1920
The Raad Zeid
Al-Hussein Collection

FIG.41 (below left)
The artist in Ottoman style veil, Büyükada, Istanbul, 1918
Necmi Sönmez Archive

1915

Fahrünnisa paints *My Grandmother*, her earliest known surviving work.

8 January – The British War Council launches an operation to bombard and take the Gallipoli peninsula, with Istanbul as its objective. Mustafa Kemal, a previously unknown colonel, successfully defends the peninsula and, after months of fighting, the Allies call off the offensive.

1916

During the War, Fahrünnisa attends Pension Braggiotti, a private school, where she continues her French-style education. She also receives private tuition in Turkish, French and English.

16 May – Confident that the Ottoman Empire will be defeated in the First World War, the United Kingdom and France secretly sign the Sykes–Picot Agreement (officially known as the Asia Minor Agreement) defining their mutually agreed spheres of influence and control in south-western Asia.

8 June – Hussein ibn Ali al-Hashimi, Sharif and Emir of Mecca declares the Arab Revolt, with the aim of securing independence for the Hijaz from the ruling Ottoman Turks and creating a single, unified Arab state from Aleppo in Syria to Aden in Yemen.

October – The British government sends numerous officials to assist in the Arab Revolt and represent the Allied cause in Arabia, including Captain T.E. Lawrence ('Lawrence of Arabia'), who advises Sharif Hussein and his four sons, Ali, Faisal, Abdullah and Zeid. Prince Zeid Al-Hussein, Sharif Hussein's youngest son, later marries Fahrünnisa.

1917

The Russian Revolution dismantles the Tsarist autocracy, leading to the eventual rise of the Soviet Union.

1918

30 October – The Armistice of Mudros is signed by the Ottoman Minister of Marine Affairs, Rauf Bey, and the British admiral Sir Somerset Arthur Gough-Calthorpe, effectively ending Ottoman participation in the First World War.

11 November – Germany signs an armistice agreement prepared by France and the United Kingdom. Two days later, in accordance with the Armistice of Mudros, British, French and Italian forces begin to occupy Istanbul, dismissing the Ottoman parliament and ministries and seizing control of all government departments.

1919

January – Fahrünnisa begins her studies at the İnas Sanayi-i Nefise Mektebi (Academy of Fine Arts for Women) in Istanbul, where the influential female painter Mihri Müşfik is director.

19 May – The Turkish War of Independence begins under the leadership of Mustafa Kemal.

1920

10 August – The Treaty of Sèvres is signed, awarding much of the Ottoman Empire's territory in the Levant to various Allied Powers as protectorates.

Autumn: Fahrünnisa marries İzzet Melih Devrim, President of the Imperial Ottoman Tobacco Company and a well-known writer. For their honeymoon, the couple travel to Venice, where Fahrünnisa is impressed by classical Venetian Painting. The nineteen-year-old joins her husband's household, which consists of his widowed mother, an aunt and an eight-year-old daughter from a previous marriage.

1921

15 June – Fahrünnisa and Devrim's first son, Faruk, is born in Istanbul.

Winter – Devrim publishes his novel *Hüzün ve Tebessüm* (Sadness and Smile), establishing the fame of the Fecr-i Ati movement of modernist Ottoman literature.

1922

1 November – The Grand National Assembly of Turkey (founded 23 April 1920) abolishes the Sultanate and Caliphate. Mehmed VI, the thirty-sixth and last sultan of the Ottoman Empire, is expelled from Istanbul.

1923

French painter Roger Bissière becomes professor of painting and drawing at the Académie Ranson in Paris, a position he holds until February 1939.

July 1 – Fahrünnisa and Devrim's second son, Nejad, is born in Istanbul.

24 July – The Turkish War of Independence ends and the Treaty of Lausanne is signed between the Allied Powers and the country that would soon become the Republic of Turkey.

6 October – Turkish National Movement troops enter Istanbul.

29 October – The Republic of Turkey is proclaimed, with Ankara as the capital city. Mustafa Kemal, the leader of the Turkish independence movement, becomes the country's first president, embarking on a period of modernisation and fundamental political, cultural and economic reforms.

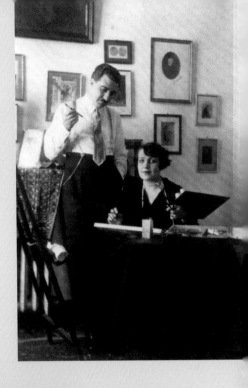

FIG.42 (above)
The artist and İzzet Melih Devrim in their apartment, Istanbul, early 1920s
The Raad Zeid Al-Hussein Collection

FIG.43 (left)
The artist in a Chanel outfit, Istanbul, 1925
Necmi Sönmez Archive

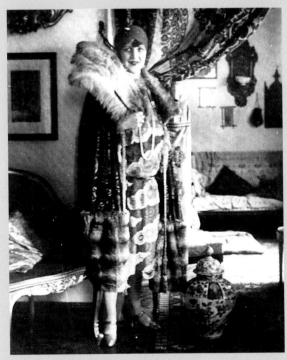

1924

Remide, Fahrünissa's stepdaughter, contracts scarlet fever.

May – Faruk, Fahrünissa's first-born, contracts scarlet fever and dies suddenly.

Summer – Fahrünissa and Devrim travel to Italy, visiting Venice, Florence and Rome. Fahrünissa sketches whenever possible while travelling. On her return to Istanbul, she immerses herself in her work.

1926

3 March: Fahrünnisa and Devrim's third child, Şirin, is born in Istanbul.

Summer – The couple continue to travel in Europe, visiting Berlin, Munich and Brussels, where Fahrünnisa visits museums and art galleries.

September – İnas Sanayi-i Nefise Mektebi (Academy of Fine Arts for Women) merges with the İstanbul Güzel Sanatlar Akademisi (Academy of Fine Arts).

1928

Autumn – Fahrünnisa travels to Paris and enrols in classes with Bissière at the Académie Ranson for nearly two months. It is a defining moment in her career.

1 November – The new Turkish alphabet is introduced by the Language Commission at the initiative of Mustafa Kemal, replacing the previously used Perso-Arabic script.

1929

February – On her return to Istanbul, Fahrünnisa enrols in classes at the İstanbul Güzel Sanatlar Akademisi (Academy of Fine Arts), studying life and pictorial composition with Namık İsmail, and portrait painting with Feyhaman Duran. Dissatisfied with the conservative teaching methods she encounters at the Academy, she leaves without a degree and begins to pursue alternative approaches.

15 July – Müstakil Ressamlar ve Heykeltıraşlar Birliği (The Society of Independent Painters and Sculptors), the first modernist Turkish art movement, is established. The group hold their first exhibition in Ankara, showcasing a range of approaches previously unseen in Turkey.

24 October – The Wall Street stock market crash begins. This day becomes known as Black Thursday (with Black Tuesday the following week) and marks the beginning of the ten-year Great Depression. İzzet Melih Devrim suffers significant financial losses.

1930

Spring – Prince Zeid Al-Hussein, the younger brother of Emir Abdullah of Transjordan, is appointed as the first ambassador of the newly established Kingdom of Iraq to the Republic of Turkey. Although based in Ankara, Prince Zeid Al-Hussein spends his summer vacations with family members in Istanbul at the famous, art-deco Park Hotel. Fahrünnisa and Devrim live next door, at the Hayırlı Apartment.

1933

30 January – Adolf Hitler is appointed chancellor of a coalition government composed of the National Socialist German Worker's Party and German National People's Party.

September – d Grubu (d Group), a new association of modernist artists, is established in Istanbul. This avant-garde group initiates exhibitions, talks and publications and has an important influence on the development of modern art in Turkey. Fahrünnisa will later join the d Group.

1934

Fahrünnisa meets Prince Zeid Al-Hussein at a luncheon at the Greek embassy.

Fahrünnisa and İzzet Melih Devrim divorce.

FIG.44
Zeid with Şirin and Prince Raad, Berlin, 1937
The Raad Zeid Al-Hussein Collection

Fahrünnisa and Prince Zeid Al-Hussein marry in Athens. Nejad and Şirin, Fahrünnisa's two children from her previous marriage, remain in Istanbul with their father.

September – The newly married couple move to a villa in Büyükdere on the European bank of the Bosphorus and Fahrünnisa establishes a studio there. In a diary entry, she writes:

> Zeid spends his days pruning trees, and I paint. We are living on a faraway hill like old retired people; yet we are still in our mid-thirties. This is not the sort of life we should be leading. Zeid should get back in [the] harness. He must return to work and take part in the world again in places where important decisions are made.[1]

Fahrünnisa begins to paint a series of expressionist Bosphorus landscapes and interior scenes in soft colours.

1935

Autumn – Prince Zeid Al-Hussein is appointed the first ambassador of the Kingdom of Iraq to Germany and the couple relocate to Berlin.

Although Fahrünnisa frequently visits museums and art galleries in Germany, she devotes much of her time to the diplomatic duties associated with being an ambassador's wife. She quickly establishes herself within society circles and, on the invitation of Adolf Hitler, visits the Führer for tea at the Reichkanzlei (Reich Chancellery) and discusses their mutual interest in painting.

1936

18 February – Prince Raad, Fahrünnisa and Prince Zeid Al-Hussein's only child, is born in Berlin. Nejad and Şirin now move to Berlin.

1937

Summer – Fahrünnisa visits the *Exposition Internationale des Arts et Techniques dans la Vie Moderne* in Paris (25 May–25 November). She also visits the Palais de la découverte, which has a strong impact on her.

FIG.45
The artist and Prince Zeid Al-Hussein with Şirin and Prince Raad, Baghdad, 1938
The Raad Zeid Al-Hussein Collection

1938

9 March – In an attempt to stave off *Anschluss* and preserve Austria's independence, Kurt Schuschnigg, the Chancellor of the Federal State of Austria, schedules a plebiscite on the issue of unification.

11 March – Hitler sends an ultimatum to Schuschnigg demanding that he hand over all power to the Austrian Nazis or face an invasion. A day later, the 8th Army of the German *Wehrmacht* crosses the border into Austria, resulting in the annexation of Austria into Nazi Germany. In the Kingdom of Iraq, pro-German sentiments gain traction, a concern for the pro-British Minister of Foreign Affairs.

30 March – Prince Zeid Al-Hussein is recalled from his post as Ambassador of the Kingdom of Iraq to Germany.

September – Fahrünnisa arrives in Baghdad for the first time. There she starts to paint and sketch local subjects: Bedouin women and ancient sites such as Babylon, Nineveh and Kerbela. She spends her time reading, writing, sketching and listening to classical music. During this time, however, she begins to suffer from depression and, on the advice of a doctor, travels to Paris.

WELTBAD **|||** KARLSBAD

1939

1939

July – Fahrünnisa leaves Paris and returns to Istanbul. Soon thereafter she experiences chest pains, fainting spells, depression and extreme nervousness. Seeking respite, she travels to a famous spa at the Hotel Gellért in Budapest. However, her condition does not improve and she soon returns to Istanbul. Three months later, Fahrünnisa travels to Budapest again to concentrate on painting. Although painted some years later, *Budapest, the Express between Budapest and Istanbul* 1943 (no.5) reveals the significance of this period in her life. In reference to this painting, Fahrünnisa said:

> I painted myself in black, and from that day on, I appeared in all my paintings as a sombre, tragic and lonesome being.[2]

1 September – Germany invades Poland. Two days later, after a British ultimatum to Germany to cease military operations is ignored, the United Kingdom and France declare war on Germany, effectively beginning the Second World War.

15 September – Nejad begins studying at the İstanbul Güzel Sanatlar Akademisi (Academy of Fine Arts), with French artist Léopold Lévy. There he takes an interest in Byzantine mosaics and Ottoman calligraphy and rapidly establishes himself as one of the leading artists in Istanbul.

October – Alone in Budapest, Fahrünnisa suffers a third bout of depression. Unable to paint, she enters the Siesta Sanatorium, where she attempts suicide. She recuperates in Hungary and returns by the end of the year to Istanbul, where she spends the winter living in a hotel.

1941

May – Nejad participates in the group exhibition *Liman/Harbour* at the Matbuat Birliği (Association of Printing Houses) in Istanbul. Around this time he also contributes to the founding of Yeniler Grubu (The Newcomers Group) and begins to engage in important debates relating to Turkish modernism.

Summer – Fahrünnisa starts working in her Büyükdere studio again.

FIG.46
Zeid in Karlsbad, 1939
The Raad Zeid Al-Hussein Collection

1943

Spring – A productive time for Fahrünnisa, who begins to develop a rich, heavily detailed and intensely colourful style in paintings like *Beshiktas, my Studio* 1943 (no.2) and *Third-class Passengers* 1943 (no.6). Later this year, her style will become more enigmatic and symbolic, as seen in works like *Three Ways of Living (War)* 1943 (no.12) and *Three Moments in a Day and a Life* 1944 (no.11).

Late summer – Celebrated Turkish art critic Fikret Adil visits Fahrünnisa's studio. He admires her work and introduces her to the d Group.

1944

16 May – Fahrünnisa is invited to join the d Group and exhibits her paintings at the group's eleventh exhibition at the İstanbul Güzel Sanatlar Akademisi (Academy of Fine Arts).

9–27 December – Nejad opens his first solo exhibition at the Taksim Belediye Gazinosu (Taksim Municipality Casino).

1945

March – Two of Fahrünnissa's paintings are included in the twelfth d Group exhibition at the İsmail Oygar Art Gallery, the first commercial gallery in Turkey.

14–24 April – Fahrünnisa organises a solo exhibition in her Ralli apartment, a twelve-room flat in Maçka, a fashionable residential area in Istanbul. The exhibition leaflet lists 172 exhibited paintings and drawings, the titles of which refer to Istanbul, Baghdad, İzmir, Kerbela and Budapest. *Three Ways of Living (War)* 1943 features on the exhibition leaflet cover. In the subsequent literature, Fahrünnissa's first solo exhibition in Istanbul is dated 1944.

30 April – Hitler commits suicide in Berlin.

8 May – The Allies accept Germany's surrender. However, the conflict continues to rage in the Pacific.

July – Celebrated Turkish composer Rakım Erkutlu writes a song for Fahrünnisa.

6 August – An atomic bomb ('Little Boy') is dropped on Hiroshima, Japan, by U.S. Army forces. Sixteen hours later, the President of the United States of America, Harry S. Truman, calls for Japan's surrender.

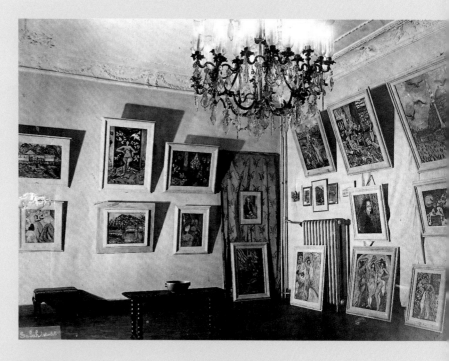

FIG.47 (above)
Zeid's first solo exhibition, Ralli Apartment, Istanbul, 1945
Necmi Sönmez Archive

FIG.48 (below)
Zeid and Nejad with *Three Ways of Living (War)*, Istanbul, 1945
Necmi Sönmez Archive

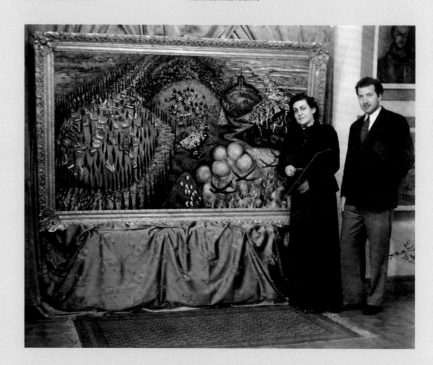

FIG.49
'Fahrünnisa Zeid', Ralli Apartment,
Istanbul 1946
The Raad Zeid Al-Hussein Collection

9 August – A plutonium bomb ('Fat Man') is dropped on Nagasaki, Japan. Six days later, Japan surrenders, effectively ending the Second World War.

A solo exhibition of Fahrünnisa's work opens at the Halkevi (People's House) in Izmir, one of many community centres in Turkey that were founded under a state-sponsored enlightenment project aimed to educate the population and increase support for the new republic's reforms. These centres are a hub for education and culture from 1932 onwards.

1946

11–31 May – Fahrünnisa holds a second solo exhibition in her Ralli apartment in Istanbul.

Prince Zeid Al-Hussein is appointed the first Ambassador of the Kingdom of Iraq to the Court of St James's, London.

The couple move to London, where Fahrünnisa establishes a studio on the third floor of the Iraqi Embassy at 22 Queen's Gate.

July – The inaugural Salon des Réalités Nouvelles is organised by Fredo Sides at the Musée des Beaux-Arts de la Ville de Paris.

September – Nejad settles in Paris and soon becomes a protégée of Gertrude Stein, the American novelist, poet, playwright and art collector. Simultaneously, he establishes close friendships with Serge Poliakoff, Sonia Delaunay and Tristan Tzara and begins to participate in numerous important group exhibitions.

October – Şirin, Fahrünnisa's daughter, attends Barnard College, New York, and, later, Yale School of Drama, New Haven. Around this time she anglicises her name, spelling it Shirin. She goes on to perform widely as an actress and teach drama in several American universities. She also becomes the first female director of the İstanbul Şehir Tiyatrosu (Istanbul City Theatre).

18 November – 28 December – Fahrünnisa presents two works in the Turkish section of the *Exposition Internationale d'Art Modern* at the Musée d'Art Moderne de la Ville de Paris. This is the first time Fahrünnisa and Nejad exhibit together.

30 November – Fahrünnisa participates in the exhibition *Peinture Turquie d'aujourd'hui et d'autrefois* at the Musée Cernuschi, Paris.

FIG.50
'Fahrünnisa Zeid'
exhibition,
St George's Gallery,
London, 1948
The Raad Zeid
Al-Hussein Collection

FIG.51
Queen Elizabeth
(The Queen Mother)
and Zeid outside
St George's Gallery,
London, 1948
The Raad Zeid
Al-Hussein Collection

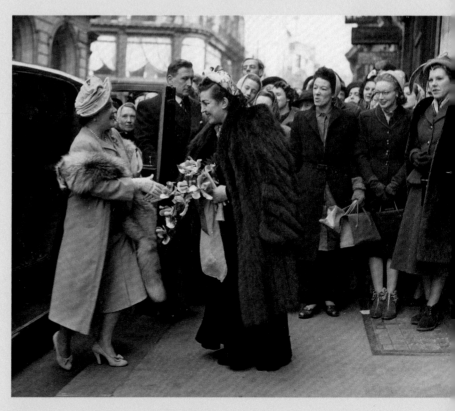

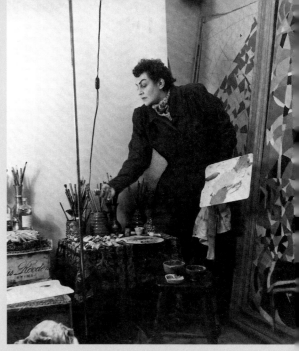

December – Fahrünnisa rents a studio at
10 rue Jean-Bart in Paris and begins dividing
her time between London and Paris.

1947

Fahrünnisa paints *Fight against Abstraction*
1947 (Dispute contre l'Abstraction) (no.16).
Thereafter her works become increasingly
abstract.

September – Three of Fahrünnisa's paintings
are included in the fifteenth d Group exhibition
at the Fransız Kütüphanesi (French Library),
Istanbul. Following this exhibition, the group
becomes less active and, later, disbands.

November – Aliye Berger, Fahrünnisa's
sister, arrives in London and begins
learning printmaking.

December – Art critic Fikret Adil publishes
his seminal book *d Grubu ve Türkiye'de Resim*
(d Group and Painting in Turkey), which
includes an image of one of Fahrünnisa's
interior paintings.

1948

5–28 February – Fahrünnisa holds a solo
exhibition, including fifty-seven paintings, works
on paper and prints, at St George's Gallery
in London. The exhibition is visited by many
dignitaries, including Queen Elizabeth, the
mother of Elizabeth II. The exhibition is reviewed
by Turkish art critic and future prime minister
of Turkey, Bülent Ecevit.[3] It is also favourably
reviewed by Maurice Collis in *Time and Tide*,
who states:

> Zeid is evidently an artist to be taken very
> seriously. She has made a first appearance
> which would be hard to parallel. No doubt
> we shall hear a great deal more of
> her later on.[4]

Later, Collis, who becomes a long-term friend,
suggests to the artist that she should host a
regular salon at the Iraqi Embassy.

Several members of the Salon des Réalités
Nouvelles steering committee resign following
various internal disputes. Under new leadership,
the Salon grows quickly and begins to attract
an increasing number of foreign artists.

1949

Fahrünnisa's style begins to change dramatically
as she embraces abstraction and starts to break
up each image into colourful, mosaic-like shapes
bound by thick black lines. Although the subject
is still discernible in works like *Tents* 1948 (no.17)
and *Abstract Parrot* c.1948–9 (no.18), it is clear
her style is shifting dramatically. This new work
begins to attract attention in France.

January – Fahrünnisa participates in a group
exhibition at Gimpel Fils in London. Enamels by
Suzanne and Pierre Fremont are included in the
show, alongside fifteen paintings and fifteen
works on paper by Fahrünnisa, the titles of
which reference particular places in the United
Kingdom, but also Paris and Baghdad.

9 March – Fahrünnisa hosts her first salon in
London. She continues to hold extravagant
parties for dignitaries, politicians, celebrities
and artists at the Iraqi Embassy, until the coup
d'etat in 1958. By this time she is a renowned
hostess in London and has become friendly with
many artists and intellectuals, including Lynn
Chadwick, Henry Moore, César (Baldaccini),
Marc Chagall, Giorgio de Chirico, Roland
Penrose, Lee Miller, Kathleen Raine, Louise
Rainer and Steven Runciman.[5]

Spring – Fahrünnisa exhibits three paintings in a group exhibition at City Art Gallery, Bristol.

During this year Fahrünnisa arabicises her name and begins to be referred to as Her Royal Highness Princess Fahr-El-Nissa Zeid. Several journalists pick up on this and begin to refer to her as 'The Painter Princess'.

2 December – Fahr-El-Nissa's first solo exhibition in Paris takes place at Galerie Colette Allendy. There, she meets Dina Vierny. The exhibition leaflet contains a foreword by French author André Maurois and a short text by the art critic Denys Chevalier. Art critic Léon Degand reviews this exhibition in the magazine *Art d'Aujourd'hui*:

> Fahr-El-Nissa Zeid paints with the urgency of someone who has mastered painting for the first time. The colour is fierce; the draughtsmanship complex; the fragrance occasionally too strong. A certain sense, however, of sweeping rhythms.[6]

1950

9–29 January – The Hugo Gallery, New York, presents *The Oriental Painter, Fahr-El-Nissa Zeid*, the artist's first solo exhibition in America.

The exhibition is organised by the Greek gallerist and collector Alexander Iolas and focuses on Fahr-El-Nissa's abstract paintings.

1951

31 May – An exhibition of Fahr-El-Nissa's abstract works opens at Galerie de Beaune, Paris. Simultaneously, a limited edition titled *Midi Nocturne* (Nocturne at Noon) with four original abstract lithographs and an introduction by the prominent French art critic Charles Estienne, is published by Editions de Beaune. This is the beginning of a long-term friendship, which has a significant impact on Fahr-El-Nissa's career.

Summer – Fahr-El-Nissa illustrates a special issue of *Poetry London*, published to coincide with the Festival of Britain.

8 June – 15 July – The large abstract painting *My Hell* 1951 (no.31) is exhibited at the sixth Salon des Réalités Nouvelles at the Palais des Beaux-Arts de la Ville de Paris.

14 July – Fahr-El-Nissa participates in a group exhibition organised by Suzanne de Coninck, director of Galerie de Beaune, with Denise Chesnay, Émile Gilioli, Charles Lapicque, Marcelle Loubchansky, Nejad, Serge Poliakoff,

Marie Raymond (Yves Klein's mother) and Gérard Schneider, at the Bar degli Artisti, Florence.

September – Füreya Koral, Fahr-El-Nissa's niece, opens her first solo exhibition of ceramics and lithographs at Galerie M.A.I. in Paris. While Füreya was recovering from tuberculosis in a Swiss sanatorium in the 1940s, Fahr-El-Nissa had visited and encouraged her to play with clay as a form of therapy. Once recovered, Füreya studied classical Iznik ceramics; she later becomes one of the leading ceramic artists in Turkey. She remains close to Fahr-El-Nissa, who designs exhibition posters for her.

December – *Témoignages pour l'art abstrait* (Testimonials for Abstract Art) by Julian Alvard and Roger van Gintertael is published. This is an important survey of abstraction, and many of the leading artists of the day contribute full-page *pochoir* plates, including Fahr-El-Nissa, Jean Arp, Sonia Delaunay, Serge Poliakoff, Nicolas de Staël and Victor Vasarely.

FIG.54
My Hell 1951, 6th Salon des Réalités Nouvelles exhibition, Palais des Beaux-Arts de la Ville de Paris, 1951
The Raad Zeid Al-Hussein Collection

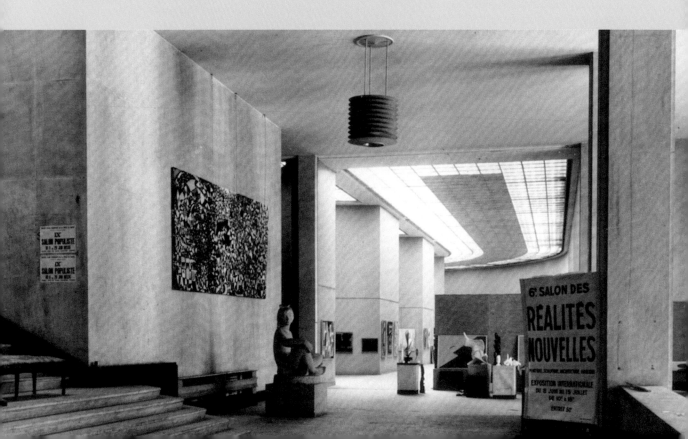

1952

12 February – Fahr-El-Nissa participates in the important group exhibition *Peintres de la Nouvelle École de Paris* with eighteen other artists, including Arnal, Jean-Michel Atlan, Pierre Dmitrienko, Jean Messagier, Nejad and James Pichette. This exhibition is curated by Charles Estienne at the Le theatre de Babylone, Paris and is the first time Estienne refers to those artists experimenting with lyrical abstraction in post-war Paris as *Peintres de la Nouvelle École de Paris*.

Spring – Fahr-El-Nissa's first solo exhibition in Switzerland opens at Galerie 16, Zürich. In this exhibition she presents painted stones together with her paintings. The exhibition is favourably reviewed by a Swiss art critic in *Sie und Er Magazine*:

> The paintings are also accompanied by painted stones, which are of particular interest to the princess. Here, some motif or other – buried within the form of the stone, a pure natural formation – is highlighted in an often astonishing way through simple lines and colour planes, or rather, brought out to the surface. And even this type of creative design reveals a rich imagination, one which finds its expression in the cascade of a colourful firework.[7]

1 July – Fahr-El-Nissa participates in a group exhibition, *Rose de L'Insulte*, at La Hune, Paris, with Chagall, Lapicque, Loubchansky, Messagier, Mortensen, Nejad, Poliakoff, Raymond Jean Degottex, René Duvillier, Roberta Gonzales, Hans Hartung, Hans Reichel and Pichette.

20 July – Fahr-El-Nissa exhibits two works in the seventh Salon des Réalités Nouvelles, Musée des Beaux-Arts de la Ville de Paris.

Summer – Fahr-El-Nissa and Prince Zeid Al-Hussein begin spending their summer holidays on the island of Ischia, Italy, where she starts painting abstract works inspired by the landscape and marine world.

16 December – Fahr-El-Nissa participates in a group exhibition with Lapicque, Loubchansky, Messagier, Nejad, Poliakoff, Louis Pons and Laviolle at Galerie Suzanne Michel, Paris.

1953

10–23 April – Fahr-El-Nissa participates in a group exhibition curated by Charles Estienne, with François Arnal, Degottex, Duvillier, Loubchansky, Messagier and Alfonso A. Ossorio at Galerie Craven, Paris. Estienne continues defending lyrical abstraction and proclaims the total freedom of gesture in his writings.

FIG.55
Zeid (centre) with Charles Estienne (left), 1950s
Necmi Sönmez Archive

FIG.56
Julian Alvard and Roger van Gintertael, *Témoignages pour l'art Abstrait*, Art d'aujourd'hui, Paris 1952

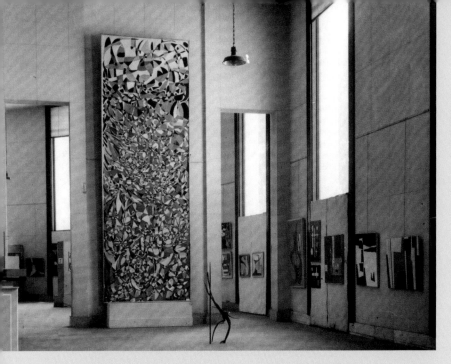

FIG.57
Towards a Sky 1953 (Vers un Ciel),
8th *Salon des Réalités Nouvelles*
**exhibition, Musée des Beaux-Arts
de la Ville de Paris, 1953**
The Raad Zeid Al-Hussein Collection

on paper, at Dina Vierny's gallery in Paris. On the occasion of this exhibition, a limited-edition book containing a short artist's statement and texts by Charles Estienne and Jacques Lassaigne and designed by the Mourlot brothers is published. Fahr-El-Nissa designs the exhibition poster.

1954

23 February – Paule Vézelay writes to Fahr-El-Nissa, inviting her to join a London branch of Groupe Espace, an association founded in Paris in 1951 by André Bloc and artists associated with his journal *Art d'Aujourd'hui*.

May or June – Fahr-El-Nissa purchases an apartment at 39 rue de Grenelle, Paris, and relocates her studio there.

9–31 July – The majority of paintings and drawings from Fahr-El-Nissa's 1953 exhibition at Galerie Dina Vierny are transported to London. These works are presented in a solo exhibition at the Institute of Contemporary Arts, which Roland Penrose officially opens. Fahr-El-Nissa is at the height of her career. In his contribution to the exhibition leaflet, Maurice Collis writes:

10 July – 9 August – Fahr-El-Nissa participates in the eighth Salon des Réalités Nouvelles at Musée des Beaux-Arts de la Ville de Paris with a single work, titled *Towards a Sky* 1953 (Vers un Ciel) (fig.57).

13 September – Aliye Berger wins the first prize in an important competition held by the first Turkish private bank, Yapı ve Kredi Bankası. A panel of respected international judges comprising Sir Herbert Read, Lionello Venturi and Paul Frierens, in Istanbul for the Interna-tional Association of Art Critics congress, judge the competition. Berger, a self-taught artist known for her etchings, creates a furore by winning with her first oil painting on canvas. This is a significant moment in Turkish art history.

4 December – 7 January 1954 – Fahr-El-Nissa exhibits a group of eleven recent large-scale abstract paintings, including *The Octopus of Triton* 1953 (no.25), *Sargasso Sea* 1953 (no.27) and *Intermittence ... Sand ... Water ... Sun* 1953 (no.34), together with twenty-four works

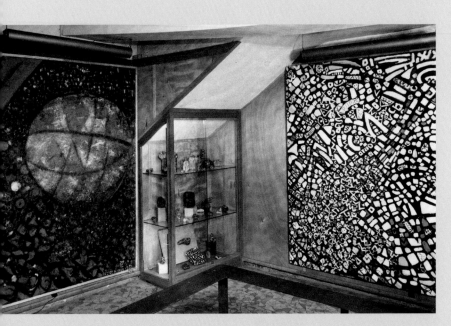

FIG.58
**'Fahr-El-Nissa Zeid' solo exhibition,
Galerie Dina Vierny, Paris, 1953**
Tate Archive

Her painting, resting as it does on a wider personal experience of life and thought than is to be found inside any one country, is a more authentic unfolding of personality than can ever be a style which is chiefly the result of study.[8]

29 November – 18 December – Fahr-El-Nissa participates in the important group exhibition *Aspects of Contemporary French Painting*, presented by Effie Damoglou at Parsons Gallery, London. The exhibition presents works by sixty Paris-based artists, including Jean Esteve, Hartung, André Masson, Nejad, Édouard Pignon, Man Ray, Jean-Paul Riopelle, Maria Helena Vieira da Silva, Pierre Soulages and Ossip Zadkine.

Winter – Eminent Turkish artist and art critic Nurullah Berk publishes the book *Modern Painting and Sculpture in Turkey* in English. He writes:

> Zeid is well known in European artistic circles since she exhibits with success in the principal artistic capitals. This artist wife of the Iraki [sic] Prince Zeid formerly possessed a lyrical but realistic vision has now arrived at pure abstraction. She attacks large canvases with courage composing with passion and patience surprising puzzles of scattered or

massed forms such as atomic bursts of cubes, lozenges or squares, or strange spider webs woven with black and brilliant as stained-glass windows.[9]

1955

1 March – Fahr-El-Nissa participates in a group exhibition titled *Alice in Wonderland* curated by Charles Estienne at Galerie Kléber, Paris. Bernard Childs, Corneille (Guillaume Beverloo), Degottex, Duvillier, Roger-Edgar Gillet, Simon Hantaï, Jan Krizek, Loubchansky, Toyen (Marie Čermínová) and Thanos Tsingos also participate.

29 October – 15 November – Galerie Dina Vierny, Paris, presents an exhibition of work by Poliakoff, Pichette and Fahr-El-Nissa.

8 November – An exhibition of Fahr-El-Nissa's gouaches and lithographs opens at La Hune, Paris.

21 November – André Breton writes to Fahr-El-Nissa:

> I forever hold deep within my heart the echo of the words which came to me here from you, like a beam emanating from those superb geodes which grow and expand at will from your fingers, which is strong enough to penetrate all the darkness.[10]

1956

14 January – Fahr-El-Nissa presents two works in the Turkish section of the *Première exposition internationale de l'art plastique contemporain* at the Musée des Beaux-Arts de la Ville de Paris.

13 March – 15 April – Charles Estienne invites Fahr-El-Nissa to participate in the group exhibition *L'Ile de l'homme errant* at Galerie Kléber, Paris. Chagall, Émile Compard, Degottex, Duvillier, Loubchansky and Toyen also participate.

Summer – Colour lithographs by Fahr-El-Nissa are included in the fourth biennale at the Cincinnati Art Museum in Ohio.

10–28 November – Galerie Aujourd'hui presents the exhibition *Peintures et statuettes de Fakhr-El-Nissa Zeid* (sic) at the Paleis voor Schone Kunsten, Brussels.

FIG.59
**'Fahr-El-Nissa' exhibition,
Institute of Contemporary Arts,
London, 1954**
Tate Archive

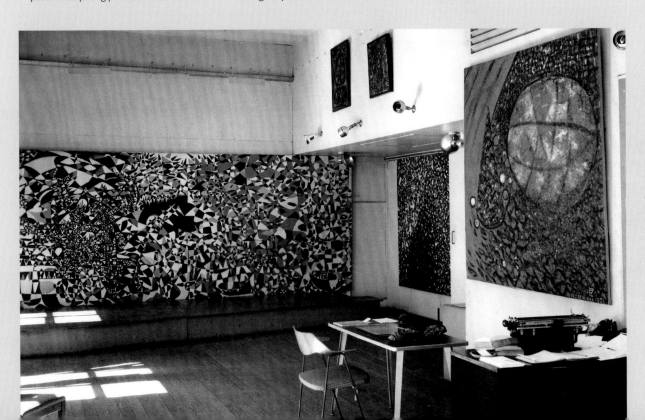

1957

5 June – 5 July – The Lord's Gallery opens in Philip Granville's house and garden, opposite Lord's cricket ground in London, with an exhibition of Fahr-El-Nissa Zeid. This exhibition includes twenty-three paintings, twenty-one drawings and sixty-three painted stones, which attract attention in the press. *Towards a Sky* 1953 (frontispiece), a 6-metre tall painting, which is too large to fit in the gallery, is exhibited in the garden. In his review of the exhibition, George Butcher writes about this work:

> It was punctured around the edges and strung into place like a sail on a yawl. Further inventions were carried out so that it became entirely enveloped in a pliofilm covering to ward off the vagaries of English weather. The result was particularly spectacular just before sunset, when the light became even and without reflections from the sun. Its geometrical forms receded from consciousness as the entire glowing entity took over and dominated the space and life and mood of the garden; it seemed truly to grow in some organic way up out of the ground and towards the sky.[11]

When this work was exhibited at the Institute of Contemporary Arts in 1954, only the bottom two thirds were on view, with the rest in a roll at ceiling level.

Summer – Fahr-El-Nissa is included in the touring exhibition *Modern Turkish Painting* at the Edinburgh International Festival with the painting *Forbidden Sun* n.d. This exhibition later travels to Aberdeen, Glasgow and Muthesius Gallery, London. British writer and journalist Derek Patmore writes in his preface:

> A characteristic of all Turkish women artists is that there is little femininity about their painting. Instead there is a harsh power in the work of Eren Eyüboğlu, and even the work of Fahr-El-Nissa Zeid, although she uses colour with an Oriental opulence, has a masculine orderliness about it.[12]

1958

2 May – Fahr-El-Nissa hosts her last party at the Iraqi Embassy, to celebrate the twenty-third birthday of Prince Zeid Al-Hussein's great nephew, King Faisal II, King of Iraq.

14 July – The Hashemite monarchy in the Kingdom of Iraq, established by Faisal I in 1921, is overthrown in a coup d'état. Faisal II and Prime Minister Nuri al-Said are assassinated, together with the rest of the royal family. Prince Zeid Al-Hussein, who is on holiday in Ischia with Fahr-El-Nissa and their son at the time, is the only member of the royal family to survive. He is, however, immediately relieved of his post as ambassador and given 24 hours to vacate the London embassy.

End of July – Prince Zeid Al-Hussein writes to Fahr-El-Nissa:

> Clearing your studio was some job! So many paints and brushes, books, papers and clippings, not to mention all the finished and unfinished canvases. I tried my best. The whole thing was a nightmare.[13]

September – Fahr-El-Nissa and Prince Zeid Al-Hussein lease a furnished apartment in Oakwood Court, London. At the age of fifty-seven, Fahr-El-Nissa cooks a meal for the first time. Traumatised by events in Iraq and adjusting to her new life, Fahr-El-Nissa stops making art for a couple of years:

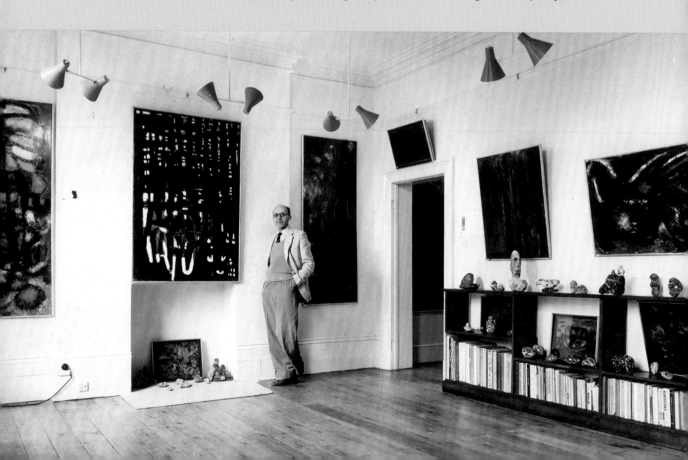

Instead of the brilliant kaleidoscope that once seemed to surround me, I can only perceive, all around me, a winding labyrinth of hard and heavy black lines. I feel lost among them, unable to emerge from the maze of my sorrow and my mourning. At most, in rare moments of composure and courage, in the last few weeks, I have been able to draw a little to sketch for instance a quite realistic portrait of my son.[14]

Maurice Collis writes about the disappearance of Fahr-El-Nissa's salons: 'The many hundreds of people who had enjoyed her parties knew they would never see the like again. There was no other woman in English society who could take the place of this Turkish Highness.'[15]

1960

Édouard Roditi, a translator, poet and art critic, and old friend of Fahr-El-Nissa's, publishes the book *Dialogues on Art*. This book includes interviews with many leading artists, including Chagall, Mario Marini, Giorgio Morandi, Joan Miró, Oscar Kokoschka, Barbara Hepworth, Henry Moore and Fahr-El-Nissa. In this interview, Fahr-El-Nissa states:

When I am painting, [I] am always aware of a kind of communion with all living things, I mean with the universe as the sum total of the infinitely varied manifestations of being. I then cease to be myself in order to become part of an impersonal creative process that throws out these paintings much as an erupting volcano throws out rocks and lava. Often, I am aware of what I have painted only when the canvas is at last finished.[16]

1961

19 May – 9 June – After a hiatus, Fahr-El-Nissa returns with a solo exhibition of recent works at Galerie Dina Vierny, Paris. A poster designed by the artist accompanies this exhibition.

FIG.60 (left)
'Fahr-El-Nissa Zeid' exhibition,
The Lord's Gallery, London, 1957
The Raad Zeid Al-Hussein Collection

FIG.61 (right)
Fahr-El-Nissa with *The Fight of*
***the Moon and the Astronaut* 1968**
(*L'intrus, la Lune et le Cosmos*),
20 October 1968
The Raad Zeid Al-Hussein Collection

Meanwhile, Charles Estienne writes the preface for the exhibition catalogue and Fahr-El-Nissa contributes the following quote:

What the eye catches, I fix in thought. [17]

1962

Spring – Fahr-El-Nissa paints *Break of the Atom and Vegetal Life* (no.59), a monumental painting measuring 210 × 540 cm.

1963

Summer – Charles Estienne and his wife Marie-Hélène visit Fahr-El-Nissa in Ischia, where she paints a portrait of Marie-Hélène.

1964

26 May – 6 June – With encouragement from her daughter, Shirin, Fahr-El-Nissa organises her first survey exhibition in Turkey at the İstanbul Güzel Sanatlar Akademisi (Academy of Fine Arts), Istanbul. The exhibition contains forty-five paintings, thirty-five works on paper and ten lithographs, made between 1951 and 1961. An exhibition booklet with excerpts from various critics is produced on the occasion of the exhibition, which travels to the Hitit Müzesi, Ankara, where it opens on 15 June.

Fahr-El-Nissa paints *L'intrus, la lune et le cosmos*, later titled *L'affrontement de la lune et de l'astronaute* (The Fight of the Moon and the Astronaut), a major black-and-white painting that is over five metres long (no.68)

1966

29 December – Charles Estienne dies in Paris.

1969

May – Prince Zeid Al-Hussein and Fahr-El-Nissa move from London to Paris. Her studio at 39 rue de Grenelle becomes their home.

22 October – 15 November – Fahr-El-Nissa holds her first solo exhibition at Galerie Katia Granoff, Paris. The exhibition comprises paintings, and numerous polyester-resin sculptures

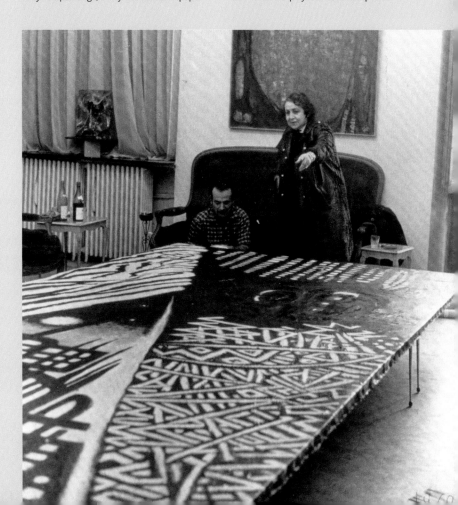

containing compositions of shells and painted chicken and turkey bones, which the artist calls *paléokrystalos*. Fahr-El-Nissa presents these sculptures rotating on 'turntables' in carefully orchestrated light conditions, making explicit her interest in light, transparency and movement. She describes their origin, thus:

> I was cleaning the turkey after our Christmas dinner when I suddenly felt the essence of the bird in its bones. Working with them I created *paléokrystalos*.[18]

On the occasion of this exhibition, a small book is published, containing poems, aphorisms and notes by Fahr-El-Nissa, as well as a portrait of the artist photographed through one of her *paléokrystalos* sculptures. This exhibition signals another turning point in the artist's career. Bernard Gheerbrant reviews it in *La Galerie Arts Lettres Spectacles Modernité*:

> In discovering the possibilities of polyester resin which make it possible to freeze shapes and colours in their three dimensions..., Fahr-El-Nissa is no doubt responding to the impulse which drives every artist of this time to find their own solution to the problem which seems technical to us but is simply the outward reflection of a deeply-felt need.[19]

November – Fahr-El-Nissa begins working on a new series of portraits, concentrating on the faces of friends and family.

1970

18 October – Prince Zeid Al-Hussein dies in Paris. This deeply affects Fahr-El-Nissa, who seeks comfort in her work and creates further large-scale enigmatic portraits of those close to her.

1972

The artist begins to drop the hyphens in her name, spelling it Fahrelnissa.

30 May – 24 June – Fahrelnissa presents her portraits for the first time in a solo exhibition, *Portraits et peintures abstraites*, held at Galerie Katia Granoff, Paris. The large-scale portraits are full-frontal or side-on, with stylised eyes and figures set against solid backgrounds, either white or intensely colourful. The subjects include Emir Zeid (no.74), Katia Granoff (fig.33), Iris Clert (no.73), Rose Larock Granoff (no.78), Charles Estienne (no.72) and René Barotte (no.76), among others. Abstract paintings like *London* ('*The Firework*') before 1972 *Le Feu d'Artifice* (no.70) and *Puncta Imperator* (*Sea Cave*) 1963 (no.69) are installed alongside the portraits. René Barotte writes an essay for the exhibition catalogue.

André Malraux, Minister of Cultural Affairs in France, visits this exhibition and the artist gives him one of her 'paléokrystalos' sculptures.

1975

Spring – Fahrelnissa packs up her studio and home in Paris and moves to Amman, Jordan, where her son, Prince Raad lives with his family. Soon she establishes a studio there and begins to teach an informal group of women students, including Princess Alia, Majda Raad, Ufemia Rizk, Hind Nassar, Suha Shoman,

FIG.62
Zeid at her exhibition
***Portraits et Peintures Abstraites*,**
Galerie Katia Granoff, Paris, 1972
The Raad Zeid Al-Hussein Collection

Jeanette Malhas, Alia Zoubiane, Leila Rizk, Janset Berkok Shami, Raab Mango and Meg Abu Hamdan. Later, the Royal National Jordanian Institute Fahrelnissa Zeid of Fine Arts is officially registered, although the lessons continue to take place in the artist's home.

1981

February – Fahrelnissa exhibits with her students for the first time in Amman. In the exhibition catalogue she writes:

In abstract painting, the unconscious part of me tries to express itself and to interpret my inner exigencies, without making a definite point fixing things. But in a portrait you have the person in front of you; the human begins with his life, his thought and his origins. In a portrait there are the structures, the colour, the forms and the spirit, a kind of a totality of art. In order to give life to a portrait I intentionally make some slight mistakes, I mean mistakes in drawing the human form, not the silks and draperies, for these must appear as they are. If the faces are shown exactly as they are the portraits will be void of dreams, of soaring, of their own language, and seem statuesque.[20]

1983

5 November – Fahrelnissa holds her first retrospective in Jordan at the Royal Cultural Centre, Amman, with over one hundred paintings, paper works, painted stones and *paléokrystalos* and forty historical photographs.

1984

21 June – Fahrelnissa participates in the group exhibition *Charles Estienne & L'Art á Paris 1945–1966* at the Fondation Nationale des Art Graphiques et Plastiques, Paris, with her painting *Alice in Wonderland* 1952.

September – Fahrelnissa visits Istanbul for the last time.

Autumn – *Fahrelnissa Zeid*, edited by French art critic André Parinaud, is published. This monograph contains excerpts from critics, biographical information and nearly one hundred colour plates.

1986

25 November – 25 January 1987 – The exhibition *La Voie Royale 9000 ans d'art au royaume de Jordanie* opens at Musée du Luxembourg, Paris, including works by Fahrelnissa.

1988

January – Fahrelnissa receives the Commandeur des Arts et des Lettres from France in recognition of her significant contribution to the arts.
28 May – 5 June – Fahrelnissa presents forty

of her painted and illuminated glass panels at the Royal Cultural Centre, Amman.

19 December – 16 January 1989 – Rabia Çapa, director of the Maçka Sanat Galerisi in Istanbul, organises the artist's first exhibition in Turkey since 1964. This exhibition stimulates interest among Turkish collectors.

1989

16 April – Katia Granoff dies in Paris.

1990

7 February – 6 June – *Fahr El Nissa Zeid zwischen Orient und Okzident Gemälde und Zeichungen*, curated by Dr. Wolfgang Becker, opens at Aachen Neue Galerie–Sammlung Ludwig. In her first solo exhibition in Germany, the works are organised according to the cities in which they were made: Istanbul, London and Paris.
6 June – 26 August – Fahrelnissa participates in the three-person exhibition *Trois femmes peintres* with the Algerian Baya Mahieddine and Moroccan Chaïbia Talal at Institut du monde arabe, Paris. This exhibition is curated by

Brahim Ben Hassain Alaoui and Noha Hosni and is accompanied by a catalogue, which includes several previously published texts.

1991

5 September – Fahrelnissa dies at her home in Amman, Jordan, three months before her ninetieth birthday. She is buried next to Prince Zeid Al-Hussein in the royal cemetery in Amman.

1993

6 December – 15 January 1994 – *Prints and Drawings of Fahr El Nissa Zeid* is held at Darat al Funun in Amman.

1994

May – Turkish art dealer Yahşi Baraz begins working with the artist's estate and starts selling her works to collectors in Turkey, especially Erol Aksoy, who amasses the most important collection of the artist's work.

5–30 November – The Erol Kerim Aksoy Foundation presents a Fahrelnissa Zeid exhibition with nearly thirty works at the Cemal Reşit Rey Concert Hall in Istanbul. A catalogue with texts by Talat S. Halman and Necmi Sönmez is published.

1995

28 February – Nejad Devrim dies in Nowz Sącz, Poland.

1996

Spring – Shirin Devrim (Trainer) publishes *A Turkish Tapestry: The Shakirs of Istanbul*, a memoir based on her mother's life story.

2000

19 October – 2 December – The Erol Kerim Aksoy Foundation presents a substantial exhibition of Fahrelnissa Zeid at the Erol Kerim Aksoy Foundation Art Gallery in Istanbul.

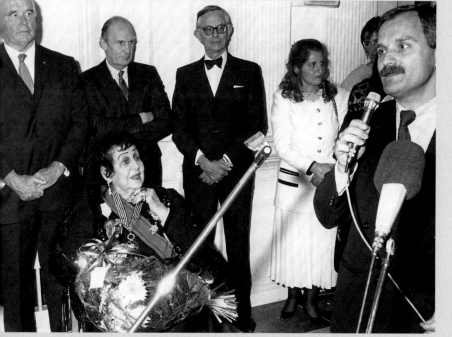

FIG.65
Zeid (seated) with Peter Ludwig, Herwig Bartels and Wolfgang Becker at the opening of her exhibition, Neue Galerie-Sammlung Ludwig, Aachen, 1990
Necmi Sönmez Archive

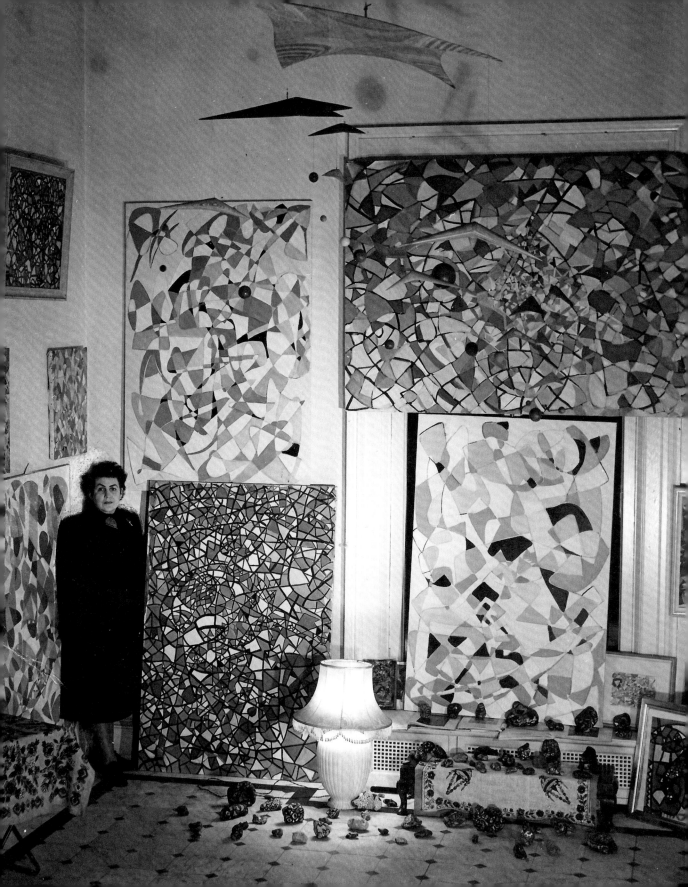

Credits

FIG.66
Zeid, Berlin, 1938

FIG.67 (overleaf)
Zeid in her living room with mobile by Lynn Chadwick, Iraqi Embassy, London, 1950s
Necmi Sönmez Archive

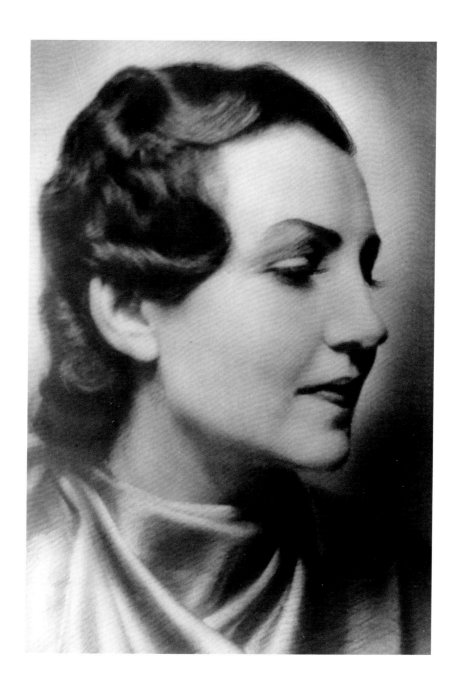

Index

Untitled c.1950s
Oil paint on canvas
182 × 222
Tate. Presented by Raad Zeid
Al-Hussein 2015 (no.33)

Break of the Atom and
Vegetal Life 1962
Rupture de l'atome et
vie végétale
Oil paint on canvas
210 × 540
Z. Yildirim Family Collection
(no.59)
(TATE MODERN AND DEUTSCHE
BANK KUNSTHALLE)

Puncta Imperator
('Sea Cave') 1963
Caverne Maritime
Oil paint on canvas
164.8 × 210.5
The Raad Zeid Al-Hussein
Collection (no.69)

Fire before 1964
Oil paint on canvas
75 × 71
Ceyda and Ünal Göğüş
Collection (no.56)

Charles Estienne c.1964
Oil paint on canvas
138 × 85
Musée d'Art Moderne de la
Ville de Paris (no.72)

Emir Zeid 1967
Oil paint on canvas
181 × 139
The Raad Zeid Al-Hussein
Collection (no.74)

René Barotte 1970
Oil paint on canvas
126.6 × 95.5
The Raad Zeid Al-Hussein
Collection (no.76)

Rose Larock Granoff 1971
Oil paint on canvas
128 × 95
Larock Granoff Collection, Paris
(no.78)

London ('The Firework')
before 1972
Le Feu d'Artifice
Oil paint on canvas
178 × 210
Berrak and Nezih Barut
Collection (no.70)
(TATE MODERN AND DEUTSCHE
BANK KUNSTHALLE)

Someone from the Past 1980
Oil paint on canvas
210 × 116
The Raad Zeid Al-Hussein
Collection (fig.15)

Suha 1983
Oil paint on canvas
100 × 90
The Khalid Shoman Collection,
Amman (no.80)

Khalid Shoman 1984
Oil paint on canvas
179.5 × 112
The Khalid Shoman Collection,
Amman (no.79)

SCULPTURES

The Man of All Times 1967
L'Homme de Tous Temps
Bone, paint and polyester resin
45 × 39.5 × 33.8
The Raad Zeid Al-Hussein
Collection (no.64)

Moon Drops 1967
Bones, paint and polyester resin
87.5 × 83.3 × 2.5
The Raad Zeid Al-Hussein
Collection (no.66)

Paléokrystalos 1969
Bone, paint and polyester resin
30 × 17.5 × 6
Istanbul Museum of
Modern Art Collection
Nermin Abadan Unat Donation
(no.65)

Paléokrystalos c.late 1960s
Bones, paint and polyester resin
28.5 × 17.5 × 2.5
The Raad Zeid Al-Hussein
Collection (no.61)

Paléokrystalos c.late 1960s
Bone, paint and polyester resin
30 × 32 × 6.3
The Raad Zeid Al-Hussein
Collection (no.63)

Untitled n.d.
Bone and paint
10.5 × 16.2
The Raad Zeid Al-Hussein
Collection (no.60)

WORKS ON PAPER

My Grandmother 1915
Watercolour on paper
25 × 21
The Raad Zeid Al-Hussein
Collection (fig.2)

Bedouin Women
(Towards Abstract) 1950
Mixed media on paper
58.4 × 45.7
The Raad Zeid Al-Hussein
Collection (no.52)

Untitled
(Brighton 9 June 1949) c.1950
Mixed media on paper
80 x 60
Sevtap and Tolga Kabatas
Collection (no.24)

Untitled 1950
Mixed media on paper
77.5 × 58
Sevtap and Tolga Kabatas
Collection (no.23)

Untitled 1963
Mixed media on paper
29.2 × 22.9
The Raad Zeid Al-Hussein
Collection (no.50)

Untitled 1971
Mixed media on paper
22.9 × 14.6
The Raad Zeid Al-Hussein
Collection (no.48)

Idols n.d.
Mixed media on paper
31.6 × 38.5
The Raad Zeid Al-Hussein
Collection (no.47)

Untitled n.d.
Mixed media on paper
72 × 53
The Raad Zeid Al-Hussein
Collection (no.45)

Untitled n.d.
Mixed media on paper
72.4 × 53.1
The Raad Zeid Al-Hussein
Collection (no.46)

Untitled n.d.
Mixed media on paper
28.5 × 22
The Raad Zeid Al-Hussein
Collection (no.51)

List of Exhibited Works

Zeid titled her early works in Turkish and later used a combination of French and English titles. Over the course of her life, the titles of works were inconsistently reproduced, and several paintings are now known by multiple titles. The most common English title is listed first with other titles in inverted commas and brackets. Where English and foreign language titles differ or where French titles are still in use, both have been included for clarity. Sculptures and drawings would all likely have been titled by the artist, but, with a few exceptions, these titles are no longer known.

PAINTINGS

Beshiktas, my Studio 1943
Oil paint on canvas
58.7 × 48.8
The Raad Zeid Al-Hussein
Collection (no.2)

Third-class Passengers 1943
Oil paint on plywood
130 × 100
Istanbul Museum of
Modern Art Collection
Eczacıbaşı Group Donation
(no.6)

Three Ways of Living (War) 1943
Oil paint on plywood
125 × 205
Ela Sefer (no.12)

Turkish Bath 1943
Oil paint on canvas
51.5 × 63.2
The Raad Zeid Al-Hussein
Collection (no.7)

Self-Portrait 1944
Oil paint on canvas
60 × 50
Sema and Barbaros
Çağa Collection (no.1)

**Three Moments in a Day
and a Life** 1944
Oil paint on plywood
125 × 209
The Raad Zeid Al-Hussein
Collection (no.11)

Fight against Abstraction 1947
Dispute contre l'Abstraction
Oil paint on canvas
101 × 151
Istanbul Museum of
Modern Art Collection
Eczacıbaşı Group Donation
(no.16)

Loch Lomond 1948
Oil paint on canvas
102 × 192
The Raad Zeid Al-Hussein
Collection (no.15)

Resolved Problems 1948
Oil paint on canvas
130 × 97
Istanbul Museum of
Modern Art Collection
Eczacıbaşı Group Donation
(no.22)

Abstract Parrot c.1948–9
Oil paint on canvas
106 × 155.5
Istanbul Museum of
Modern Art Collection
Eczacıbaşı Group Donation
(no.18)

My Hell 1951
Oil paint on canvas
205 × 528
Istanbul Museum of
Modern Art Collection
Shirin Devrim Trainer and Raad
Zeid Al-Hussein Donation (no.31)
(TATE MODERN AND DEUTSCHE
BANK KUNSTHALLE)

Alice in Wonderland 1952
Alice au Pays des Merveilles
Oil paint on canvas
236 × 210
The Raad Zeid Al-Hussein
Collection (no.29)

Ubu Bird ('The Phoenix') 1952
L'Oiseau Ibu-Phoenix
Oil paint on canvas
146 × 113
Sevtap and Tolga Kabataş
Collection (no.30)

Basel Carnival 1953
Carnaval de Bâle
Oil paint on canvas
200 × 280
Sammlung Ludwig, Ludwig
Forum für Internationale
Kunst, Aachen (no.26)
(TATE MODERN AND DEUTSCHE
BANK KUNSTHALLE)

The Octopus of Triton 1953
La Pieuvre de Triton
Oil paint on canvas
181 × 270
Istanbul Museum of
Modern Art Collection
Eczacıbaşı Group Donation
(no.25)

The Arena of the Sun 1954
L'Arène du Soleil
Oil paint on canvas
196 × 269.5
Istanbul Museum of
Modern Art Collection
Eczacıbaşı Group Donation
(no.28)

Shining c.1955
Irisations
Oil paint on canvas
65 × 54
Ceyda and Ünal Gögüş
Collection (no.55)

Winter – Nermidil Erner Binark, Fahrelnissa's niece, publishes *Şakir Paşa Köşkü: Ahmet Bey ve Şakirler* (The Şakir Pasha Mansion: Ahmet Bey and the Şakirs). This book provides valuable insight into the Şakir Pasha family history.

2001

6–30 May – On the centenary of the artist's birth, an exhibition of Fahrelnissa Zeid's work opens at the Art Gallery of the Türkiye Cumhuriyet Merkez Bankası (Central Bank of the Republic of Turkey) in Ankara. A catalogue is published on this occasion.

September – The Tasarruf Mevduatı Sigorta Fonu (Savings Deposit Insurance Fund of the Republic of Turkey) confiscates the prominent Erol Aksoy collection and orders a judicial sale. The Eczacıbaşı family, who are in the process of establishing the Istanbul Museum of Modern Art, negotiate directly with the authorities and purchase all the works by Fahrelnissa Zeid.

6 December – February 2002 – On the centenary of Fahrelnissa's birth, Darat al Funun in Amman, Jordan, presents an exhibition of the artist's work and publishes a catalogue with a combination of new and previously published texts by Shirin Devrim Trainer, Zeynep Yasa Yaman, Charles Estienne and Julien Alvard.

2004

Istanbul Museum of Modern Art, Turkey's first major private art museum, opens in an 8,000-square-meter dry cargo warehouse on the Bosphorus.

2006

18 May – 1 October – Istanbul Modern presents the two-person retrospective *Fahrelnissa & Nejad: Two Generations of the Rainbow* with works by Fahrelnissa interspersed with those by her son Nejad Devrim. A substantial catalogue is published to coincide with the exhibition.

2009

20 January – Dina Vierny dies in Paris.

2011

6 March – Shirin Devrim Trainer dies in New York.

2015

5 March – 5 June – Several paintings and sculptures by Fahrelnissa are included in the twelfth Sharjah Biennial (artistic director: Eungie Joo).

5 September – 1 November – Several paintings by Fahrelnissa are included in the 14th Istanbul Biennial (artistic director: Carolyn Christov-Bakargiev).

2016

February – Janset Berkok Shami publishes the book *Fahrelnissa and I*, a memoir of her own life and Fahrelnissa's after they met in Amman.

14 October – 26 March 2017 – Fahrelnissa's iconic work *My Hell* 1951 is included in *Postwar: Art between the Pacific and the Atlantic, 1945–1965* at Haus der Kunst, Munich (curators: Okwui Enwezor, Katy Siegel, Ulrich Wilmes).

2017

14 March – 23 July – Fahrelnissa's work is included in the group exhibition *Colori* at GAM and Castello di Rivoli (curator: Carolyn Christov-Bakargiev).

6 June – 15 October – Tate Modern, London, presents the first major retrospective of Fahrelnissa Zeid in the United Kingdom (curators: Kerryn Greenberg and Vassilis Oikonomopoulos). This exhibition travels to Deutsche Bank KunstHalle, Berlin (19 October 2017 – 25 March 2018) and the Nicolas Ibrahim Sursock Museum, Beirut (27 April – 1 October 2018).

1 Shirin Devrim, *A Turkish Tapestry: The Shakirs of Istanbul*, London 1996, p.92.
2 André Parinaud (ed.), *Fahrelnissa Zeid*, Amman 1984, p.41.
3 Bülent Ecevit, 'Londra'dan Sergiler'. *Ulus gazetesi*, Ankara, 15 February 1948.
4 Maurice Collis, Introduction, in *Fahr-El-Nissa Zeid: Recent Painting*, exh. brochure (texts by Roland Penrose and Maurice Collis), Institute of Contemporary Arts, London 1954, n.p.
5 Maurice Collis, *Journey Up: Reminiscences 1934-1968*, London 1970, p.104; Devrim 1996, p.175.
6 'Fahr-El-Nissa Zeid peint avec l'impétuosité d'une première conquête de la peinture. La couleur est violente; le dessin, complexe; le parfum parfois trop fort. Un certain sens ces grands rhythmes, cependant.' Fahr-El-Nissa Zeid, *Art d'Aujourd'hui*, no.6, 1950, p. 14.
7 'Zu den Gemälden gesellen sich dann noch bemalte Steine, denen das besondere Interesse der Prinzessin gilt. Hier wird in oft verblüffender Weise irgendein Motiv, das verborgen in der Gestalt des Steines, eines reinen Naturgebildes, liegt, durch einfache Linien und Farbflächen verdeutlicht oder besser: an die Oberfläche emporgeholt. Und auch diese Art des Gestaltensverrät ein reiche Phantasie, eine Phantasie, die ihren Niederschlag in der Brillianz eines farbigen Feuerwerkes findet.' Eine malende Prinzessin, *Sie und Er Magazine*, Spring 1952, n.p.
8 Maurice Collis, Introduction, in *Fahr-El-Nissa Zeid: Recent Painting*, exh. brochure (texts by Roland Penrose and Maurice Collis), Institute of Contemporary Art, London 1954, n.p.
9 Nurullah Berk, *Modern Painting and Sculpture in Turkey*, translated by Belinda Bather, Turkish Press Broadcasting and Tourist Department, Ankara 1954, p.17.
10 'Je garde pour toujours au plus secret de mon cœur l'écho des paroles qui me sont ici venues de vous, comme un rayon émané de ces admirables géodes qui naissent et s'étendent à volonté sous vos doigts, et qui est de force à percer toutes les ténèbres.' This extract is later published in an exhibition catalogue produced to coincide with Fahr-El-Nissa's 1969 exhibition at Galerie Katia Granoff: *Fahrelnissa Zeid: Peintures et Paléokrystalos*, exh. cat. (texts by André Breton), Galerie Katia Granoff, Paris 1969, p.8.
11 George Butcher, 'Fahr-El-Nissa', *Middle East Forum*, Al-Kulliyah Alumni Association of the American University of Beirut 1957, p.19.
12 Derek Patmore, 'Preface', *Modern Turkish Painting*, The Arts Council-Scottish Committee, Edinburgh 1957, p.5.
13 Devrim 1996, p.210.
14 Edouard Roditi, *Dialogues on Art*, London 1960, p.189.
15 Collis 1970, p.106.
16 Roditi, 1960, p.193.
17 'Je fixe en pensée ce que le regard surprend.' *Fahr-El-Nissa Zeid*, exh. cat. (text by Charles Estienne), Galerie Dina Vierny, Paris 1961, n.p.
18 Angela Bendt and Jim Downing, A real live princess, *Scanorama*, April 1984, p.107.
19 'En découvrant les ressources de la résine de poleyster, qui permet de figer dans un bloc de glaces des formes et des couleurs dans leurs trois dimensions, Fahr El Nissa obéit certes au mouvement qui pousse tout artiste de ce temps à résoudre pour lui-même le problème qui nous apparaît technique n'est que le reflet extérieur d'un besoin profond.' Bernard Gheerbrant, 'L'Odyssée de Fahr El Nissa Zeid,' *La Galerie des Arts Lettres Spectacles*, no.76, 1969, p.27.
20 *Fahrelnissa Zeid and her Institute*, exh. cat. (texts by artist and her students), Amman 1981, p.23.